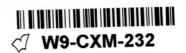
Mendocino

paintings by
David Gregory

text by
John Bear

Published by Mendocino Book Partnership
P.O. Box 463 Urbana, Illinois 61801

Paintings by David Gregory are exhibited at
the Ruth Carlson Gallery in Mendocino

International Standard Book Number 0-941509-00-1
Library of Congress Catalog Number 86-90710

Designed by Georgia-Ann Gregory using
Apple® Macintosh Plus computer and
Aldus Page Maker® software
Linotype by Precision Graphics
of Champaign IL

Color transparencies provided by
Wilmer Zehr of Champaign IL
Richard Boehme of Mendocino CA
and Art Summerfield of Santa Rosa CA
Cartography by Marilyn O'Hara
of Urbana IL

Printed and bound in Singapore
by Tien Wah Press

First edition, first printing

To Mendocino

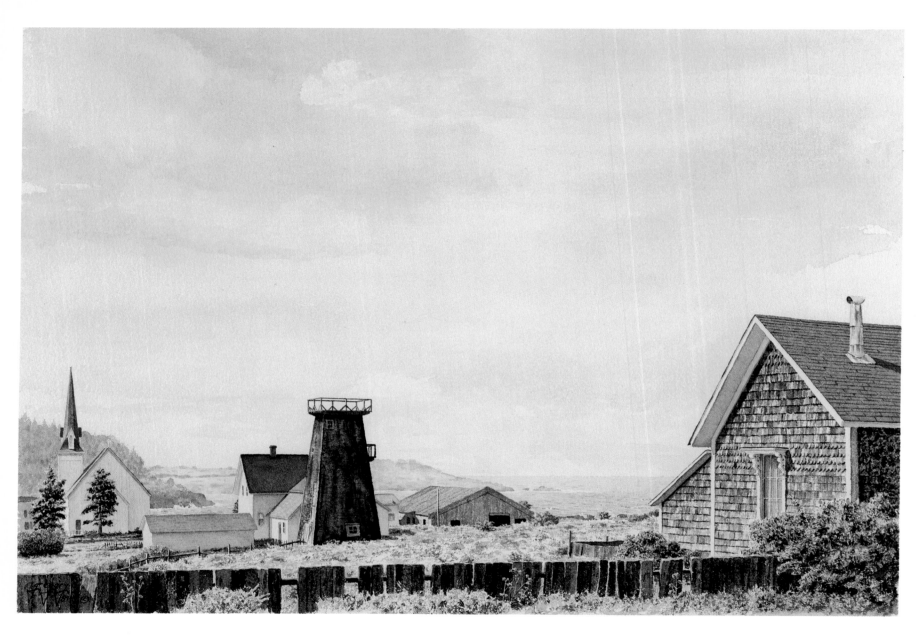

Mendocino Morning 1984
Watercolor, 15 x 22 in.
Private Collection

Mendocino

paintings by
David Gregory

text by
John Bear

First edition, first printing

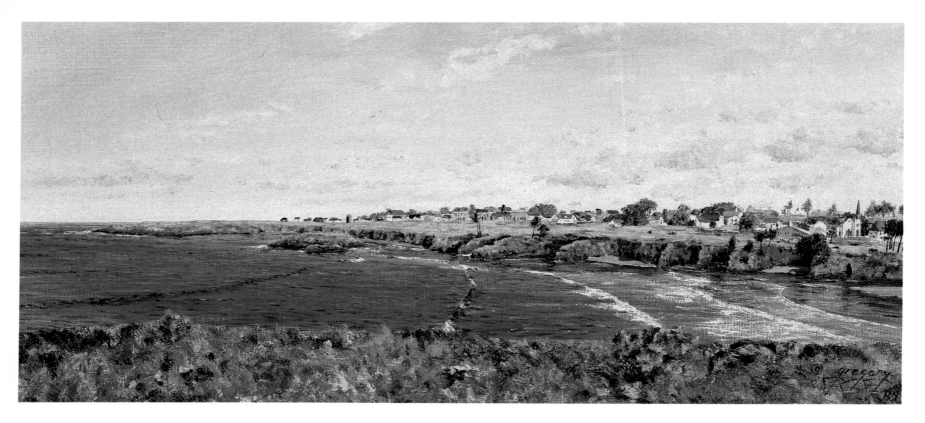

Across the Bay 1984
Oil, 10 x 18 in.
Jack and Elsie Hunn

Oh, it is truly magical. Whether you are four hours out of San Francisco with your fingers glued to the steering wheel, or you've just popped down to the Little River Market to buy a bag of coffee, that first view of the Mendocino peninsula jutting out into the Pacific Ocean sets the heart astir. It is the feeling of coming home, no matter where your legal home may be. The film and canvas people should pay royalties on this spot; it is the place nearly everyone "discovers" to record a visual image of the village. I once saw a photographer fall off his precarious fencepost perch. His companions photographed him lying on the ground before helping him to his feet.

When you turn west from the state highway toward "downtown" Mendocino, it is perhaps appropriate that the first two buildings you pass are an art gallery and a real estate office, for those are two of the mainstays of the local economy and way of life. The village may well have more real estate salespeople and artists per capita (and it is not unusual for one person to be both) than any other spot on earth.

Road to Mendocino 1986
Oil, 6 x 11 in.
Connie Young

Low Tide 1986
Oil, 14 x 32 in.

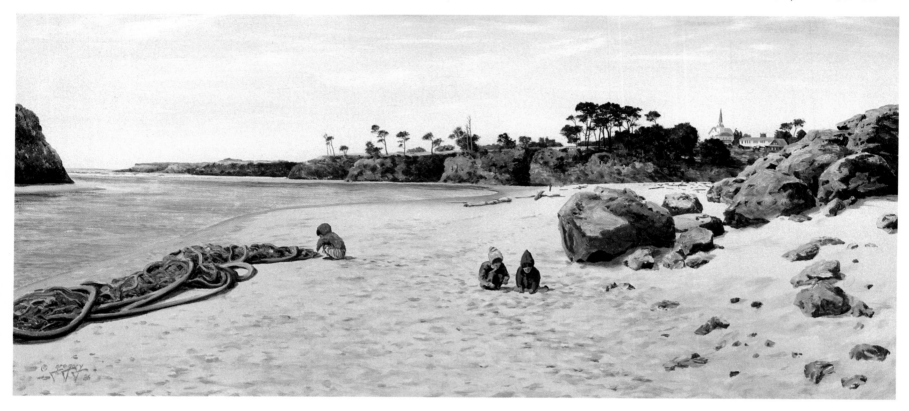

Many a tourist has arrived, beguiled by photos of Mendocino's wide sandy beaches, with bikini, sunglasses and tanning lotion in hand, only to be forcefully reminded that this is *northern* California where waterfront action is normally limited to hiking, exploring tide pools, picnics around a bonfire, and the like. Big River is a tidal river, which means that if you time it right, you can canoe or row upstream seven or eight miles with the tide, have a nice swim (because it *is* warm there) and let the tide assist you on the trip back to Big River beach.

A British visitor to Mendocino once scoffed, "Why your so-called ancient church is barely a hundred years old. Back home, that would be thought of as *new.*" Well, it's all relative, isn't it. Consider that this splendid edifice, made of native redwood locally milled, was built in 1868, less than two decades after the first white settler, William Kasten, was shipwrecked off the nearby coast.

The Presbyterian Church of Mendocino is one of the oldest Presbyterian churches in California and surely the most photographed. While the church and its members play an important role in the spiritual and social life of the community, even those who do not belong seem to take comfort from the solid, traditional landmark. It simply looks the way a church *should* look (at least to those of us who don't always appreciate the so-called symphonies of steel, glass and stone that are passed off as churches by some of today's architects). The inside, however, is unexpected. Check it out, sometime.

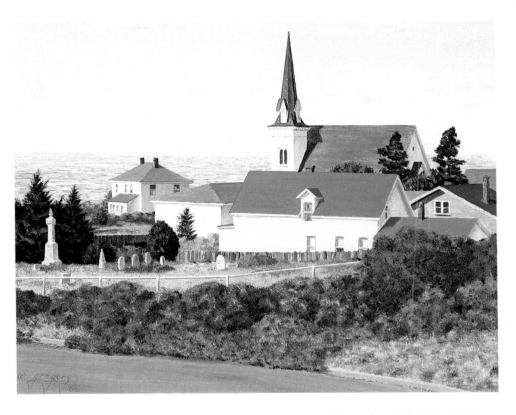

Morning Light 1986
Oil, 11 x 14 in.
Marina and John Bear

By the end of World War II, the church was badly in need of repair and a good coat of paint. To the rescue came the makers of the movie *Johnny Belinda* (starring the then Mrs. Ronald Reagan), filmed in and around the church in 1947. The fees they paid enabled the elders to bring the building to the condition in which you see it today.

Headlands Path 1986
Watercolor, 19 x 29 in.

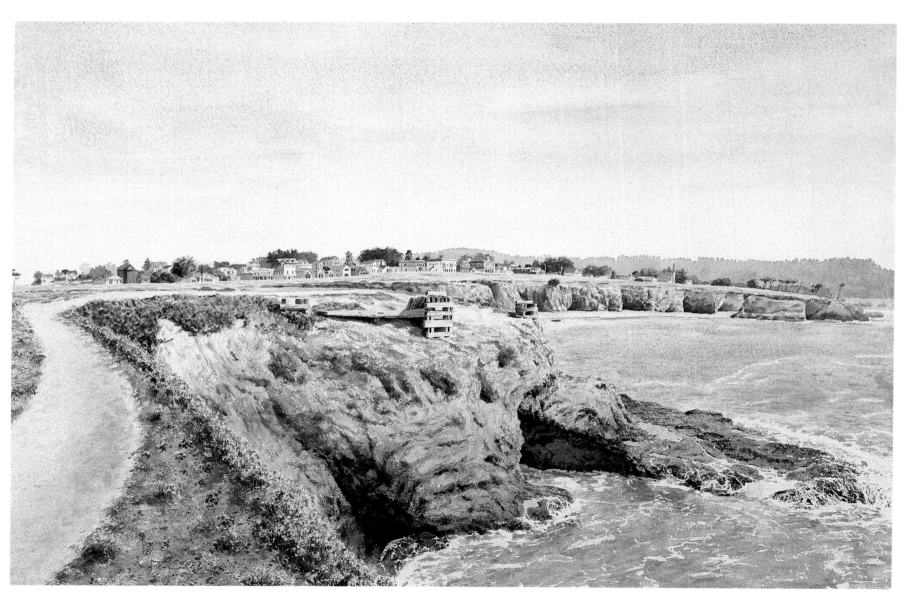

Main Street 1984
Watercolor, 11 x 22 in.
Rick and Jennifer Williams

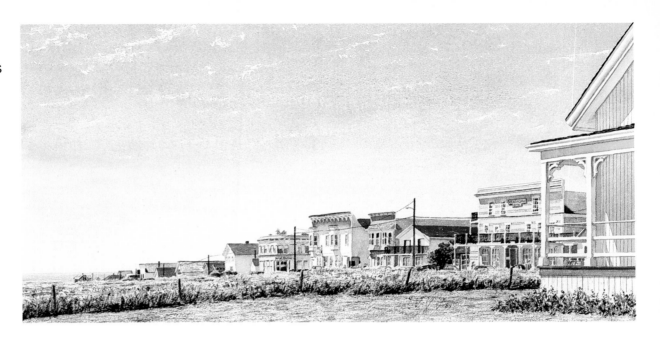

Spectacular oceanfront surrounds Mendocino on three sides, but, surprisingly, there are no ocean-front homes. There might have been, but August Heeser donated the headlands for a state park in honor of his father. Now the trails, paths, and bluffs are secure for hikers, joggers, hand-in-hand strollers, and more than a few contemplatives, each with a favorite place to sit.

It is an interesting exercise to buy one of the photo postcards of Main Street one hundred years ago, and compare it with Main Street today. The signs on the buildings have changed, and the horses have been replaced with horseless carriages but otherwise the differences are minor. Mendocino has managed to survive into the end of the 20th century without a fast food franchise, a building

taller than three stories, or a traffic light. And yet it remains a thriving, growing, modern community. Behind many of those gingerbread facades lurk sophisticated computer systems. Weathered redwood fences enclose satellite dishes. Technology may be runing rampant: in the mid 1980's, with the opening of the high school gym building, Mendocino had its first elevator!

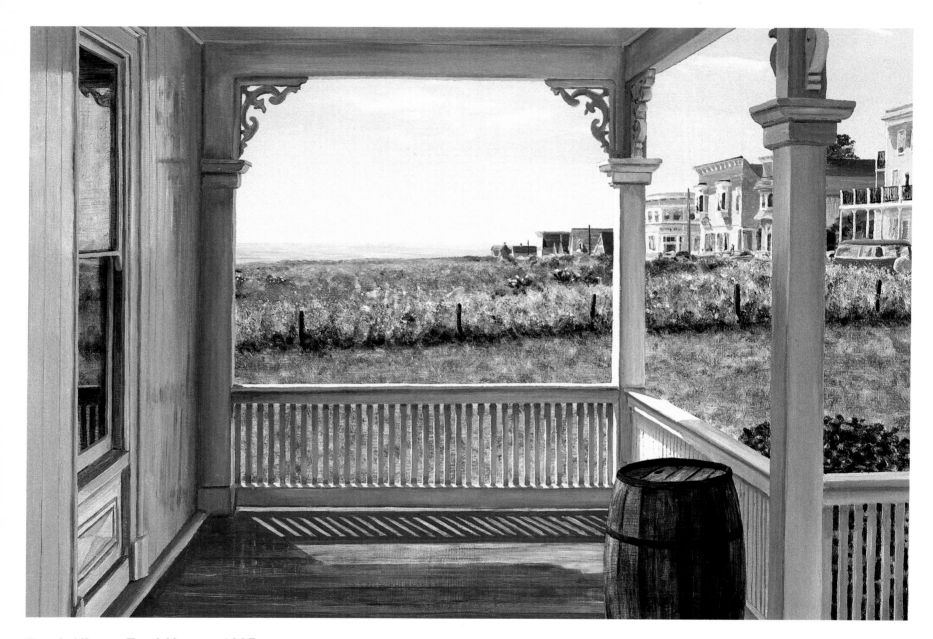

Porch View: Ford House 1985
Oil, 12 x 16 in.
Wayne and Lynne Marschall

J. B. Ford was one of the many New Englanders instrumental in the early growth of Mendocino. He came from Connecticut in 1849, helped found the lumber mill (which lasted nearly 100 years), and in 1855 commissioned the building of what he called *The Company House,* but we know as Ford House, for himself and his new Connecticut bride, Martha. Many locals, some respectable, some notorious, lived in Ford House after the demise of the last Ford, until it was taken over as the headquarters of the new State Park.

Spring Field 1985
Oil, 18 x 24 in.
Mr. and Mrs. William T. Sullivan

Until all-too-recently, the scene above might have been entitled "the road to the dump." It leads from Main Street to the place where people used to toss their garbage into the ocean. A sense of ecology arose in the 1960's, both from urban newcomers and enlightened natives. Now, nearly all trash is hauled to the county dump, bureaucratically retitled "sanitary landfill" five miles north, in Caspar. But enough is still dumped in the wrong place, one beer can or pizza wrapper at a time, to make plenty of work for the volunteer clean-up crews.

A friend of mine has a theory that many people really don't appreciate great views unless they are looking at them through a window. Certainly it is the case that Mendocino abounds in wonderful views, almost any way you turn, and yet both resident and visitor can become quite inured to them, until seeing them, as if anew, from the window of a home or the balcony of a restaurant. Fortunately my friend was deterred from his thought of proposing coin-operated shutters along the headlands. There is a wooden bench in a strategic Mendocino view spot, and carved on the back are the words, "Behold the Sea." Some people may grow indignant at the notion they might need such a reminder. But there are more than a few of us who need to be tapped on the shoulder and told, "Hey, wake up and see where you are." (Thanks.)

Fourth of July 1983
Watercolor, 9 x 15 in.
Carol Ann Walton

Bay View 1984
Watercolor, 18 x 21 in.

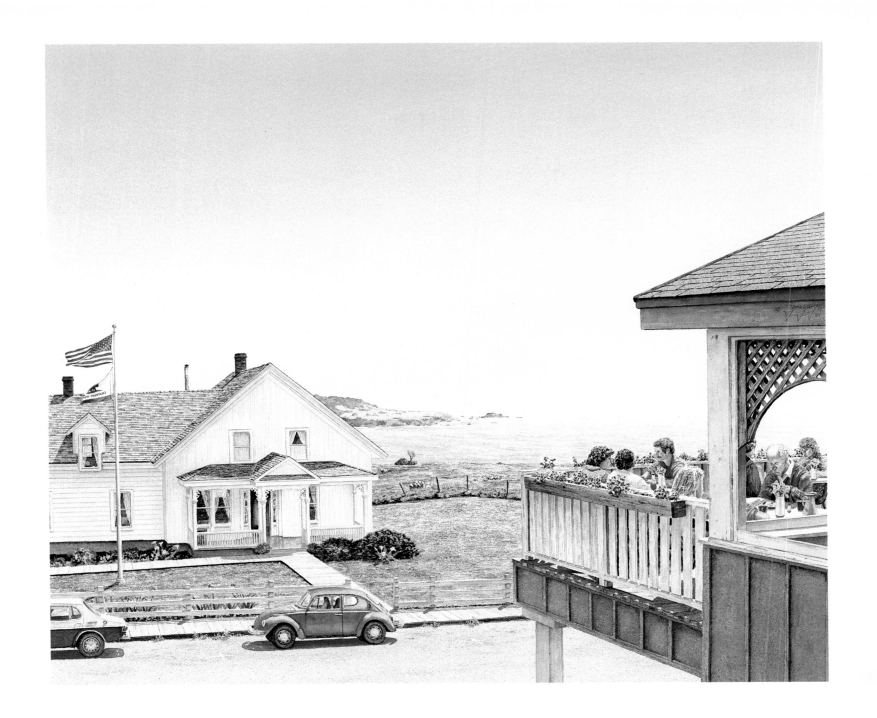

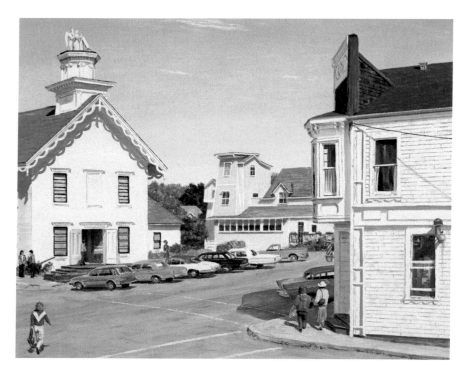

Lansing and Ukiah 1985
Oil, 12 x 16 in.
Private Collection

If, heaven forbid, Mendocino ever does require a traffic light, it will probably be at the bustling corner of Lansing (an early settler) and Ukiah (derived from the name of the Yokayo indians). In the 1970's, the Masonic order sold its hundred-year-old hall to the local bank, but retained the right to hold their meetings upstairs forever.

Every few years, Hollywood remembers that they can get that "quaint New England look" without hauling their equipment and stars all the way to the east coast. And so, to the delight of some and the annoyance of others, we find our buildings temporarily renamed and our traffic diverted. Among the photoplays with a Mendocino background are *Murder, She Wrote; East of Eden; The Russians are Coming; The Summer of '42;* and *Racing With the Moon.*

Film Day 1986
Watercolor, 20 x 23 in.

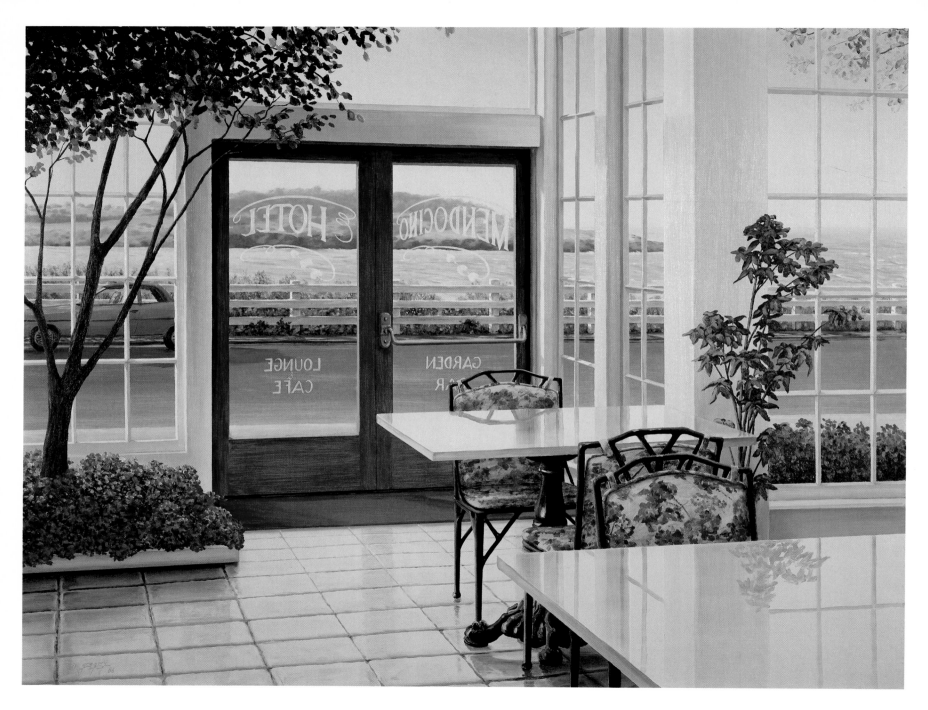

18 MENDOCINO

Garden Room 1986
Oil, 24 x 30 in.
Barry and Jo Ariko

The Mendocino Hotel is a favorite place for visitors and natives alike to relax, eat, and drink while enjoying some more of those splendid views (through the windows).

The hotel is also an important part of Mendocino's past, and has been the focus for a good deal of discussion about Mendocino's future.

The hotel traces its history to a boarding house known as The Temperance House (No Liquor Served!), opened by Ben Bever in 1878. Later the name was changed to the Central Hotel, and after Bever's retirement in the early years of this century it became the Mendocino Hotel.

In the early days, most hotel guests would arrive by freight or passenger steamboats at the Mendocino pier, where they would be met by horse and carriage and, eventually, automobiles to be brought to one of the many hotels that then lined Main Street. (Today there is only one hotel on Main Street, although some of the former hotel buildings are in use as galleries or office buildings. And today the "carriage" service meets hotel guests who fly themselves in to the Mendocino County Airport at Little River.)

For many years, the hotel was in slow decline, and by the early 1970's it could most politely be described as funky.

In the mid 1970's the hotel was acquired by a southern California industrialist whose announced plans to undertake an extensive restoration, remodeling and expansion project became *the* issue of discussion and heated debate that season.

Essentially there were three schools of thought. One held that this was just what the town needed. The Art Center began a revitalization process and the hotel project would keep the momentum going. The large sums to be spent on the project would be a boon to the local economy as would the increased number of tourists who would come to stay at the refurbished hotel.

Others worried that the fragile eco-system was ill-equipped to handle the increased need for water, sewage, parking, etc.— for this project and for what it heralded in the way of other significant tourist-related growth.

And some historical purists felt that it was inappropriate to try to recreate exactly what an elegant hotel of the Victorian era *might* have looked like. The spectre of a Mendocino "theme park" attraction was raised.

Permits were issued, the work was done, and as with most burning issues of any given day the controversy took a back seat to newer passions. Even some of the more vigorous detractors have been seen enjoying lunch in the Garden Room.

Connoisseurs of early American sign painting used to have a field day in Mendocino, where businesses that had been in operation for a half century or more still used their original signs, occasionally touched up. Today, the Mendocino Hotel and Mendosa's Market, shown here, are among the few left. Mendosa's began as a saloon in 1909 when Frank Mendosa, patriarch of the family, lost his arm in a mill accident and had to support his wife and eight children. The store was one of few in town to survive the closing of the mill in the early 1930's, (it opened briefly a few years later, then shut for good) and the great depression, both events devastating to the Mendocino economy. Today it is a thriving mercantile establishment still in the control of Frank Mendosa's descendants.

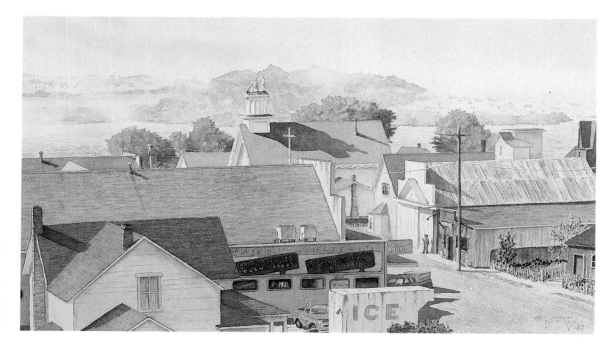

Rooftops 1983
Watercolor, 10 x 14 in.
Paul Csank

Would-be entrepreneurs used to ask, "What new business does Mendocino really need?" My answers always used to be: a travel agent, a shoe store, a Chinese take-out, and a good bakery. We got the first; the second came and went; the third hasn't happened yet; and within a short span of time there were not just one but two bakeries. Indeed they looked out over each other from opposite sides of the street.

The one surviving bakery began, as do so many successful rural businesses, on the tiniest of shoestrings, with a good idea, a minuscule space, a great product, and owners willing to spend impossibly long hours to make their dream come true.

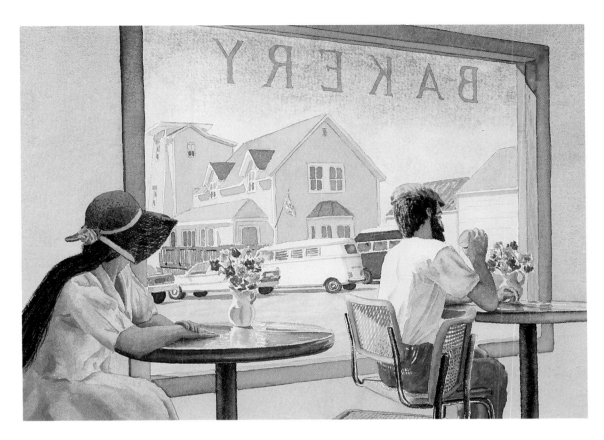

Bakery 1986
Watercolor, 10 x 13 in.

The Lisbon House deck has an especially pleasant vista, and is itself a worthy example of the decorative woodcrafter's art.

Mendocino has a long history of skilled woodworking, beginning with some of the mill workers of the 1870's whose artistic sense compelled them to do more than just make long straight boards. Happily for those who wish to build, rebuild or repair, the same turning, carving and scrollwork skills are readily available today.

When a world famous Swedish woodworker and furniture builder came to Mendocino, first to teach some seasonal courses and later to settle down, students and craftspeople came from all over to learn from the master. The unusual and superbly built furniture and decorative wood items on sale at several local galleries are testimony to their skill.

Under the tutelage of another kind of master woodworker, the Art Center has sponsored an intensive multi-year program in the art of wooden boat building.

The name of Lisbon House evokes the memory of the many Portuguese people who contributed to the growth and development of Mendocino, both in the early days and through to the present. Many settlers—Mendosa, Gomes, Fayal, Silva, Lemos, and others—came to the United States on whaling ships from Portugal and from the Azores Islands off the Portuguese coast. Some settled first on the east coast or in Hawaii but eventually came to Mendocino where land was cheap and jobs were plentiful.

A number of those who ended up working at the mill bought 40 foot by 80 foot parcels of land from William Kelley, often paying little more than a month's wages; then built their homes and often brought more family members over from the Azores or Portugal itself.

No streets in Mendocino have Portuguese names, but the area where many of the homes were built has long been known as Portuguese (or "Portugee") Flats.

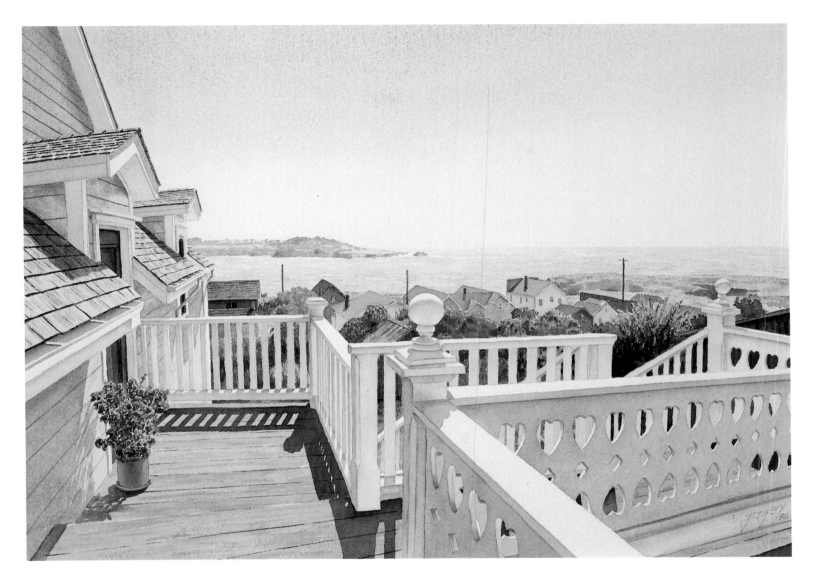

View From Lisbon House 1986
Watercolor, 14 x 19 in.

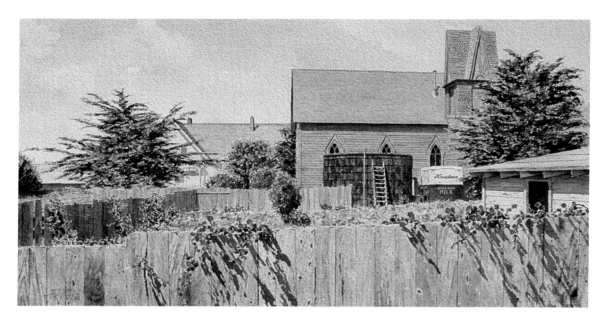

Changing Times 1983
Watercolor, 11 x 19 in.
Private Collection

Eliza Lee Kelley was the wife of William Kelley, one of the founders of Mendocino, and mother of Daisy MacCallum. She was also a Baptist, and there were not many of those in Mendocino in the early days. But as the population grew, Eliza asked her husband to build her a church. What is still known as "Eliza's Baptist Church," or "Eliza's Old Red Church" was dedicated in 1894, the year before William Kelley's death.

Eliza Kelley invited a fellow Canadian, the Reverend John Ross of Caspar, to serve in her church. Reverend Ross was a traveling preacher, calling on Baptists along a hundred miles of coastline, from Westport to Point Arena. In the Reverend Ross' absence, Eliza preached some sermons herself. The Old Red Church was in use as a Baptist church for twenty years, until Eliza's death in 1914.

After a long hiatus, Eliza's old red church again returned to community service, but this time as a natural food collective. (The Baptists had since built a new church on Little Lake Street.) The food collective caused some eyebrows to raise ("Socialism right here in Mendocino?"), but most people are pleased to find natural products not otherwise available locally.

This painting of the smallest available retail space in Mendocino is called "Hat Shop" but a few years ago it would have been "Cookie Shop" and, while currently it is "Vacant Shop" inevitably it will be something else before long.

There is a limited amount of commercial space in this area (and we're unlikely to get very much more), so it is not uncommon for a business to move around a bit, either growing larger and en route to their own building or growing smaller en route to oblivion.

Just up the coast, in Fort Bragg mercantile history was made in the early '70s when Sears (which needed more space) and arch-rival Montgomery Wards (which had too much space) agreed to swap buildings!

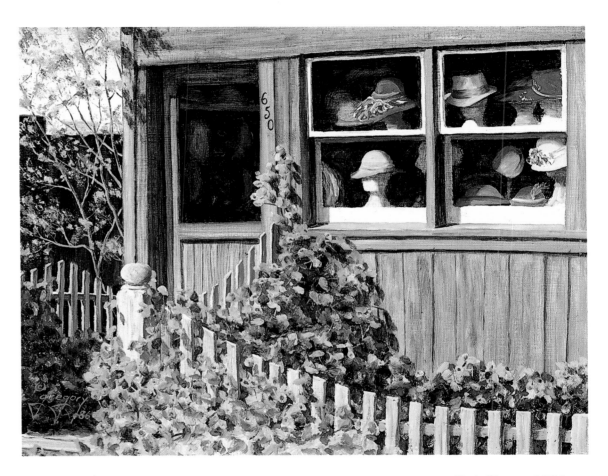

Hat Shop 1986
Oil, 8 x 10 in.
Private Collection

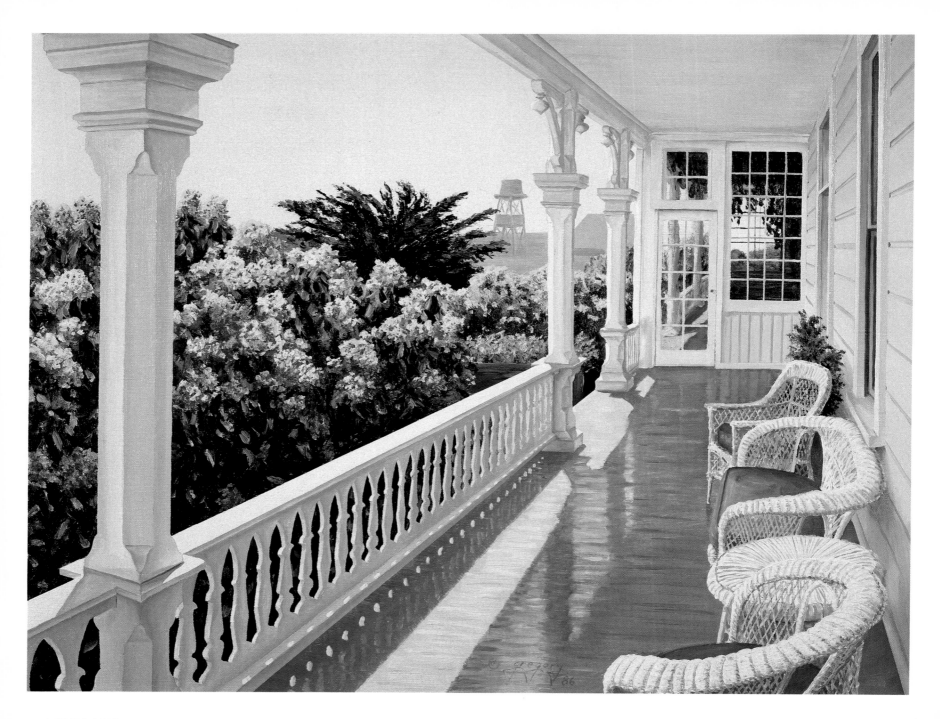

26 MENDOCINO

Wicker 1986
Oil, 14 x 18 in.
Michael and Melanie Jurlando

It is pleasant to conjure up the image of Daisy MacCallum, born in Mendocino and living with her aging son in the house that was her wedding present, well into her 90's, forty-three years a widow, rocking back and forth on her porch, perhaps watching the fishing boats that sometimes come south from Noyo Harbor into Mendocino Bay, or smiling at one of the whales that, on rare occasions, will leave its northbound pod to frolic for a short while off the headlands.

It is awesome to try to comprehand the lifespan of this woman and the changes she saw. She was born the year before Lincoln was first elected president and the only way to reach Mendocino was by sailing ship up the coast; even the first stagecoaches were quite a way off. She died as U.S. and Russian jets were engaged in dogfights in the sky over Korea.

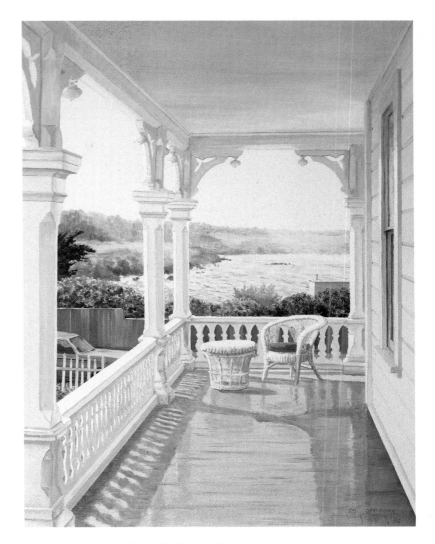

Porch View: MacCallum House 1986
Oil, 16 x 12 in.
Brian and Beverly McGill

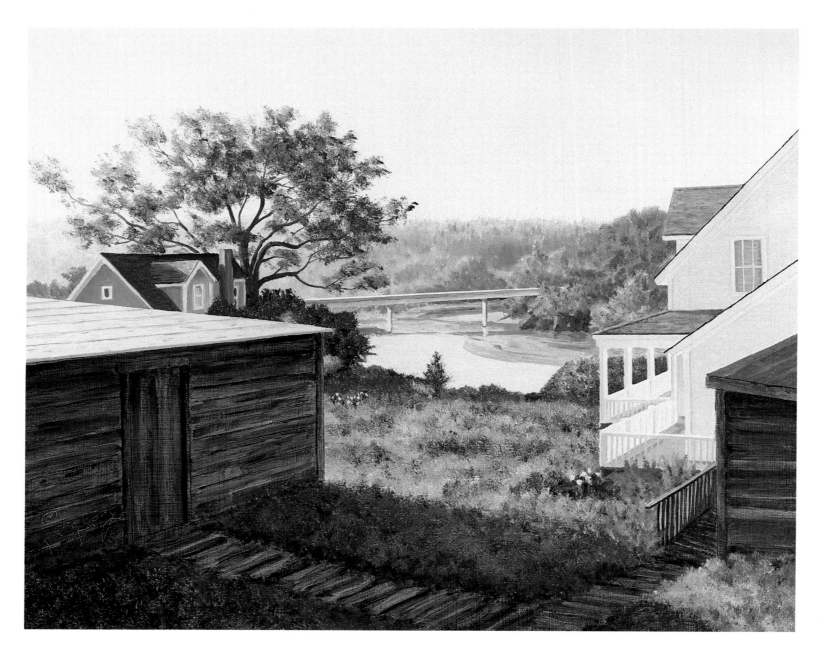

Big River 1986
Oil, 10 x 12 in.

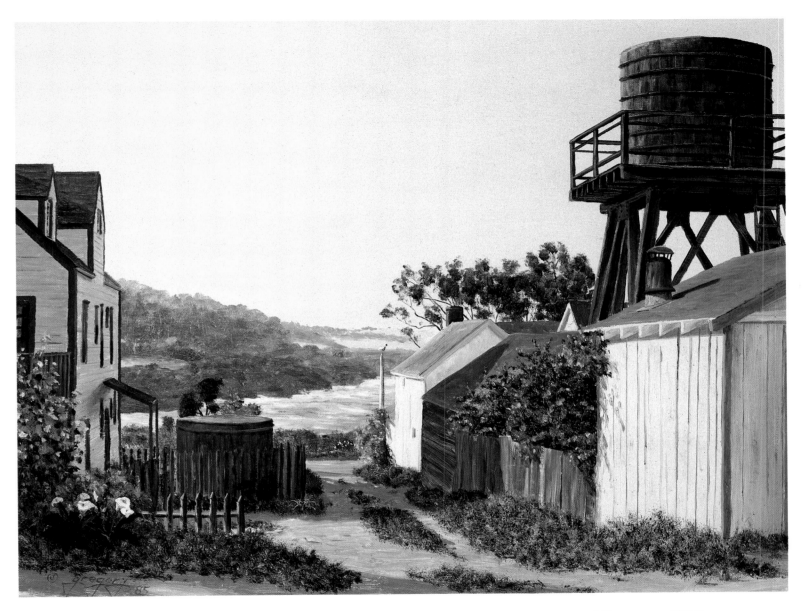

Alleyway 1985
Oil, 11 x 14 in.
Wayne and Lynne Marschall

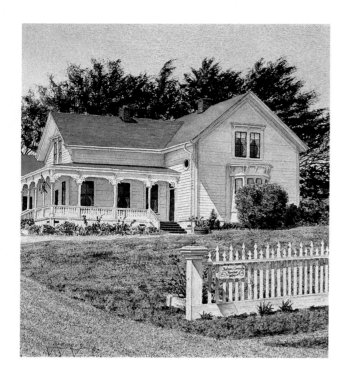

Joshua Grindle House 1982
Watercolor, 9 x 8 in.
Byron and Pat Scott

In the 1860's and 70's dozens of people emigrated from Maine to Mendocino including Joshua Grindle, who began, in 1879, to build a fine home for his new bride. Before it could be completed, Alice died in childbirth, and Joshua remarried. His second wife suffered a similar fate. It was only after his third marriage, to Mrs. Eliza Tobin, mother of two teenage daughters, that Grindle House became a place of joy and festivity. The house remained in the family until the late 1960's, and it is now an inn.

McCornack House, or the House of the Doctors was built in 1882 by one of Mendocino's early physicians, William McCornack. Twenty years later he sold it (for $1,800) to another doctor, whose widow sold it to a third, and he to a fourth. It is now (of course) an inn.

Late Arrival 1986
Oil, 8 x 13 in.

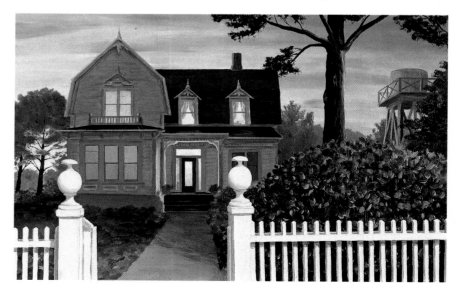

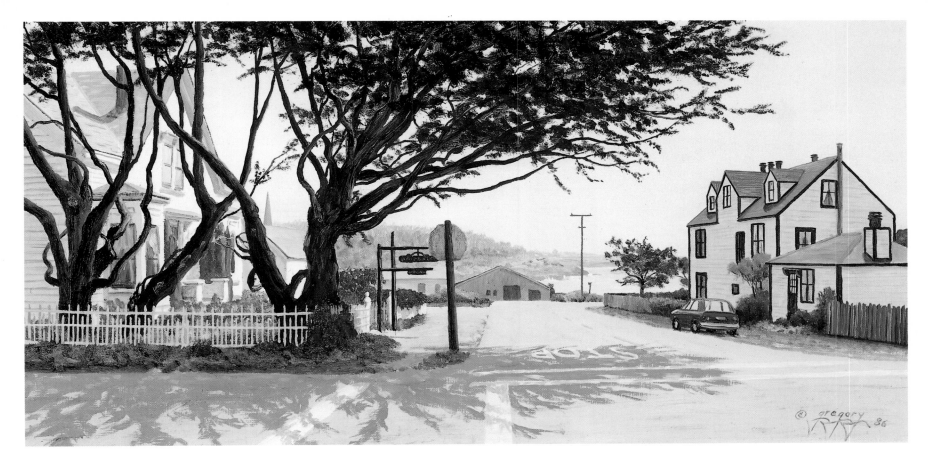

Twisted Cypress 1986
Oil, 8 x 16 in.

Dr. McCornack rented the building on the left for use as a hospital until 1895. During the 1970's it once again became a medical center, under the name "McCornack Center for the Healing Arts," which subsequently relocated to Caspar while this building became... (you get only one guess) ...an inn!

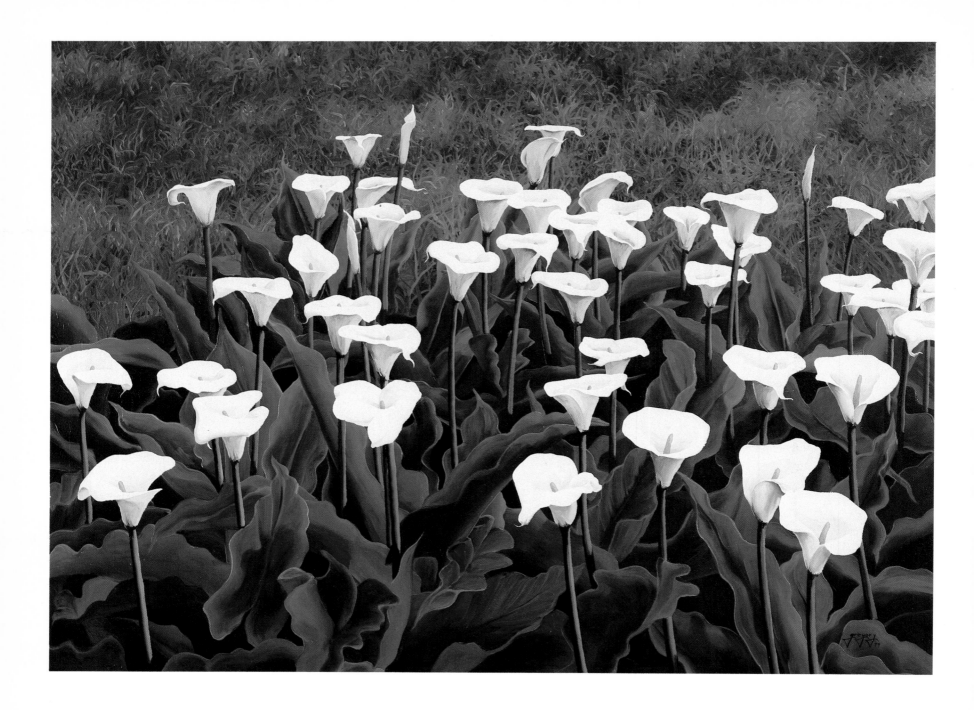

Calla lilies grow wild in and around Mendocino, and there is really nothing else quite like them.

The generally cool, often damp climate along the coast is not conducive to the *intentional* growing of many agricultural commodities other than rhododendrons and fuchsias. But Mother Nature seems to do just fine with her calla lilies, and especially with her Scotch broom, which seems bent on overrunning much of the roadside between Mendocino and Caspar to the north.

One year, we made a deal with a local farmer: he would till three acres of our coastal land, we would plant rye grass and fava beans, and all of us would share in the proceeds of the harvest. Well, the rye was sparse, the beans rotted in the ground, the tractor broke down and the farmer had a heart attack. We probably should have gone into the Scotch broom business.

Speaking of matters agricultural, the Mendocino area is, unfortunately, best known in many places for its number one cash crop, which happens to be quite illegal. A few years ago, the county's chief agricultural officer listed the estimated value of the marijuana harvest in his annual report, maintaining that it would be unrealistic to ignore it, because it not only was there, it was quite possibly the leading factor in the agricultural economy of the area. The poor man suffered great criticism and never officially mentioned the name of the vile weed again. But it didn't go away.

Calla Lilies 1979
Oil, 36 x 48 in.
Georgia-Ann Gregory

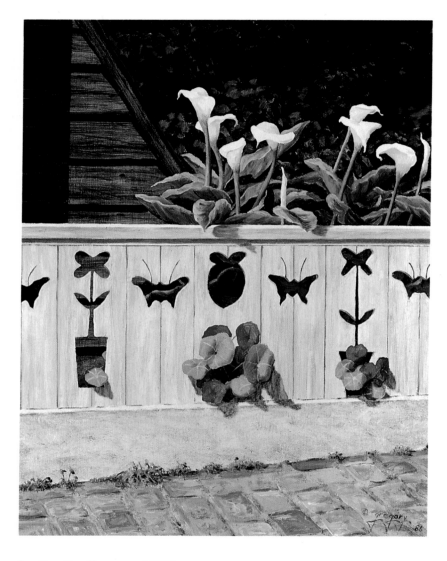

Butterfly Fence 1986
Oil, 16 x 12 in.

In Mendocino, new construction is carefully regulated (too carefully, some insist) by four agencies: the Historical Review Board, the Community Services board (sewer connections), the Planning Commission, and the state's Coastal Zone Commission. But the building of fences, and particularly the design of fences, is not one of the major worries of these regulators, especially if the fences don't block anybody's views.

And so it is in the matter of fences that the architectural and design creativity of the residents often flourishes.

Remarkably (knock on redwood), although spray paint is readily sold at several local stores, and despite the huge white surfaces, graffiti has never been a major problem in Mendocino.

Fences. If good ones make good neighbors, as Frost says, the corollary, we deduce, is that bad fences make bad neighbors. Once, near Mendocino, there were two adjoining property owners who got along harmoniously, if for no other reason than that one was an absentee owner who only came in to hunt or fish once or twice a year. The year-round resident erected a fence, partly to keep the deer out of his kitchen garden, and partly because he just liked the way it looked. But the neighbor took one look and said that first of all it was ugly, second of all it was too high, and third of all it was 18 inches onto his land. Before the courts got it all sorted out, there were charges of libel, slander, defamation of character, trespass and attempted assault. But at least it didn't turn out to be illegal to build an ugly fence.

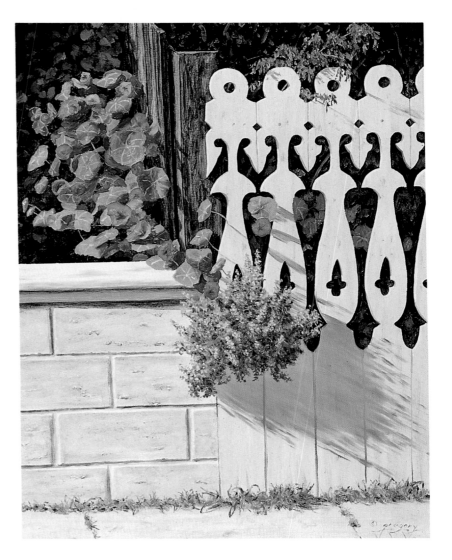

Three Fences 1986
Oil, 16 x 12 in.
Michael and Susan Bucchianeri

Holidays in Mendocino somehow seem more special than in other, larger places. One unexpected reason is that many people actually remember what the holiday is for. On Memorial Day, for instance, there are ceremonies and speeches to honor our nation's war dead. In past years, some businesses actually remained closed, in memoriam, rather than opening early to celebrate the unofficial start of the tourist season.

The Fourth of July weekend always used to be considered the start of tourist time. The locals simply acknowledged that there would now be a couple of months when the lines would be longer at the market, reservations necessary at some restaurants, and parking a little harder to find at the laundromat. But then we began to notice, each year, that these phenomena were occurring in mid-June, then early June, then over Memorial Day, and quite possibly heading right for Easter week.

There are many who lay the blame, or the praise depending on whether they are pro- or anti-growth, on the King of Saudi Arabia. It was the Arab oil embargo and its aftermath in the mid 1970's that brought Mendocino to the attention of many people in the San Francisco Bay area. "Less than a tank of gas away" became the rallying cry. Untold thousands of city folk learned that they could indeed find great meals, glorious scenery and a tranquil way of life (if only for a weekend) a mere 150 miles from their front door.

Nearly everyone agrees that *some* tourism is essential for the local economy. But there are those who would build a tollgate across Highway One at Philo, those who would build a large convention center north of Mendocino, and every shade of opinion in between.

Hidden picture puzzle: The artist (David Gregory) and his wife (Georgia Ann) can be found in this picture—somewhere in the lower right quadrant. No prizes.

Memorial Day 1985
Oil, 12 x 16 in.
Private Collection

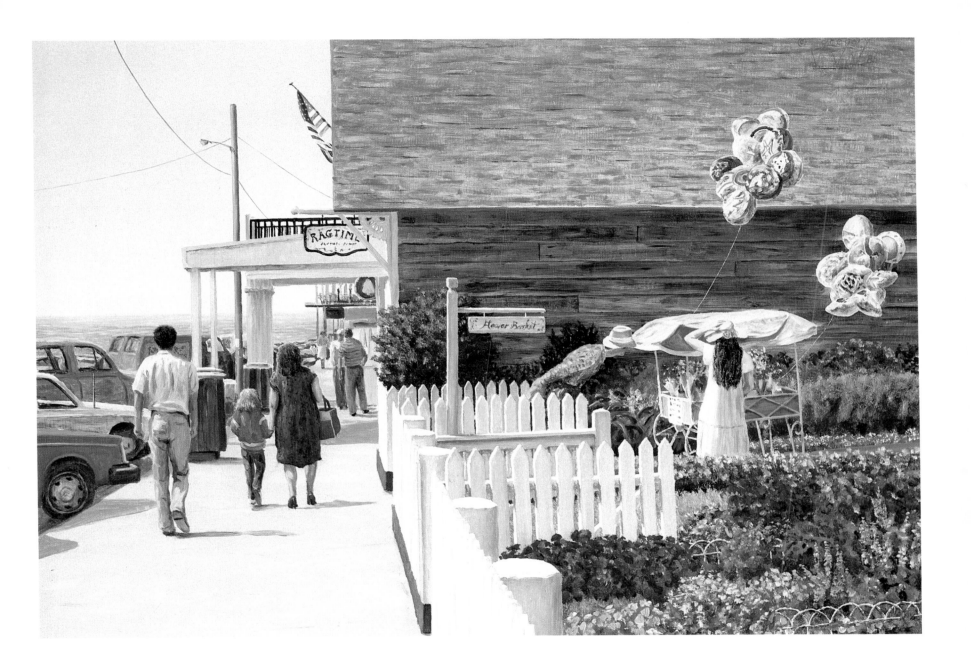

Someone once had the idea of publishing a guidebook on "Mendocino After Dark," but they abandoned the plan when they came to realize it would be about three pages long.

On the other hand, three pages isn't so bad for a small isolated village. Once the natural light show has concluded (there are often impressive sunsets, and on cloudless days, we have even seen the elusive green flash as the sun dips below the horizon), there are ample opportunities for food, drink, and entertainment.

With regard to drink, let us note that the neon martini sign on a Main Street bar is probably the only neon advertising sign in Mendocino or for miles around. The present code prohibits them, and the martini was the only one "grandfathered" in when the new laws went into effect.

Stores and galleries are rarely open during the evening. They depend so much on impulse buying and drop-in traffic, and there isn't a lot of wandering around after dark.

In addition to the half dozen or more restaurants, Mendocino supports a little theater group, an opera company, and a comedy troupe, all of whose reviews typically refer to a quality unexpected in so small and remote a region. The original movie house is now a gift shop, but films are shown regularly in the former grammar school. The former town hall has also been turned into boutiques (that sort of thing happens a lot in Mendocino), but dances and other friendly events are often held in Crown Hall (built by the Portuguese Union and now administered by the Volunteer Fire Department) and Preston Hall at the Presbyterian Church.

One after-dark (and even during the light) facility notably missing is a youth center. From time to time, the need is noticed and committees are formed to talk about it. A short-lived but fairly popular center in the basement of the high school gym burned and was not replaced.

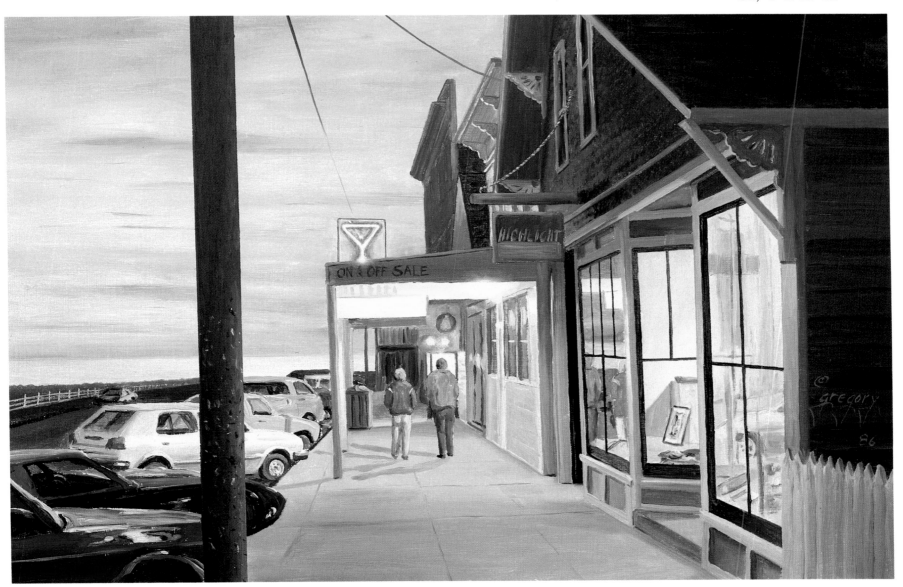

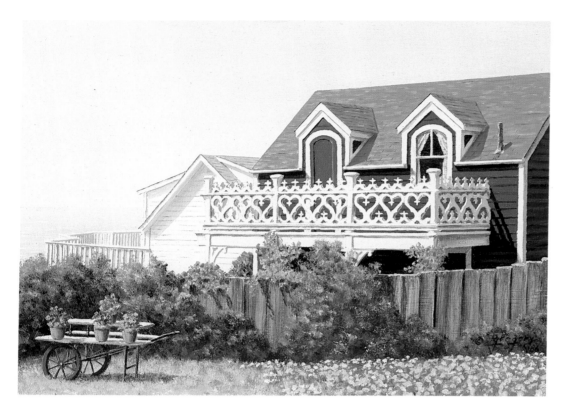

Two Balconies 1986
Oil, 9 x 12 in.
Chuck and Mary Ann Barr

Balconies. So many balconies in this world seem to look out over other balconies a few yards away. But the balconies of Mendocino inevitably have a prospect of the ocean, the town or often both. There are even a modest number of days each year when the ocean breezes are mild enough that people actually enjoy their balconies.

Much of the intricate "ginger-bread" work on balconies and trim dates from the mid to late 19th century. But there is much that is newly created; Mendocino has many outstanding woodworkers. New construction is more likely to get the needed permits if the design is compatible with, but not an exact copy of something old.

In their lovely book[1] of photographs of historical Mendocino, Dorothy Bear[2] and Beth Stebbins write that the style has "been classified as Gothic Revival, Saltbox, Gingerbread, Rustic, Pointed Cottage, Carpenter's Gothic, and once in a-while just plain awful."

[1] *Mendocino*, published by Mendocino Historical Research, Inc.
[2] No relation; of five Bears who lived in Mendocino, at least four are writers. What can this mean?

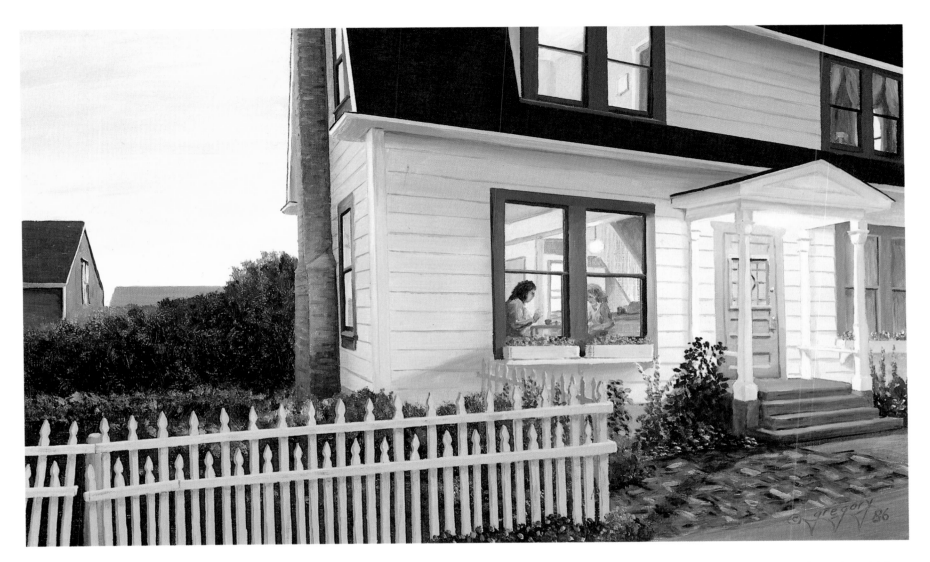

Late Snack 1986
Oil, 9 x 14 in.

Evening Reflections 1986
Oil, 10 x 10 in.

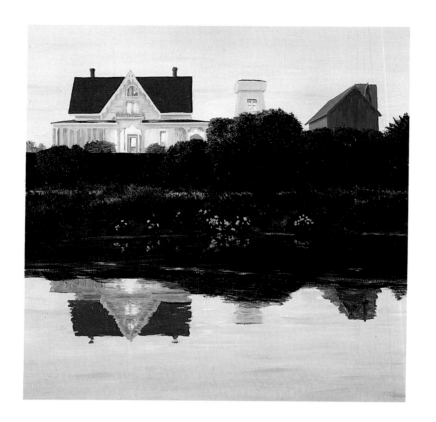

Kelley Pond, situated just off Main Street near Kelley House, is *either* the place to see the wild calla lilies, some rather aggressive geese and a lovely reflected view of the Mac-Callum House, *or* it is the place to discover that Mendocino is having another of its perennial water shortages, whereupon the pond will contain little or nothing in the way of water.

There is no public water system in Mendocino; people depend on their own wells, on the kindness of neighbors, and sometimes on the entrepreneurs with good inland wells and tank trucks. Some claim the water shortage is due to overdevelopment and construction. Others suggest that wells have been erratic in Mendocino for 130 years.

Daisy MacCallum was born in Kelley House in 1859, seven years after her father arrived in Mendocino, where he built homes, a church, and many commercial buildings. MacCallum House was a gift to Daisy and her new groom, Alexander. But for a 12-year sojourn in San Francisco, she lived there until her death at 94. MacCallum House is now an inn.

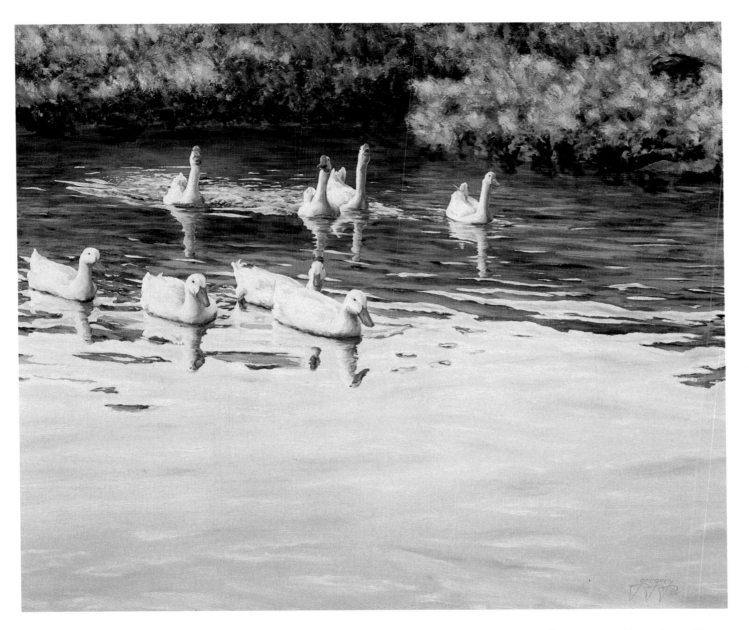

Geese and Ducks 1980
Oil, 15 x 18 in.
Georgia-Ann Gregory

The annual Pancake Breakfast, held as a fundraiser in the Fire House, is one of quite a few typical events that can be found in almost any small rural town. And yet, at first glance, many visitors seem surprised to find this sort of thing going on. It is as if they had not expected a place as special as Mendocino to have a life of its own; to have an existence that is utterly unrelated to serving the needs of visitors. Sort of like the time I discovered a garage sale going on at the back entrance to Buckingham Palace.

I remember seeing a tourist at a classy restaurant waiting in line to use the phone. Ahead of her was her waitress, who was dealing with some problem with her child in school. It was apparent when the realization set in on the tourist's face that her waitress was a real human being with an independent life entirely unrelated to bringing her an herbed cream cheese omelette. Mendocino is special to residents and visitors alike, but a good deal of very ordinary stuff goes on here.

The Mendocino Volunteer Fire Department is indeed an all-volunteer force. When the siren sounds, their phones ring, or their beepers go off, these brave and highly-trained people drop whatever they may be doing and rush to the place where they are needed.

As often as not, the fire department is called out to deal not with fires but with medical emergencies of all kinds, and with people who have fallen from the headlands, or been swept away by a giant wave.

City people, who are happy to visit Mendocino but find it hard to imagine living here year 'round, often ask just what is the appeal; how is it better. One answer that some understand is this: until not all that long ago, the way you alerted the Volunteer Fire Department was by dialing a special phone number that *automatically* set off the wailing fire sirens. No human intervened. And the system was virtually never abused. Can you imagine that happening in New York or Chicago or San Francisco?

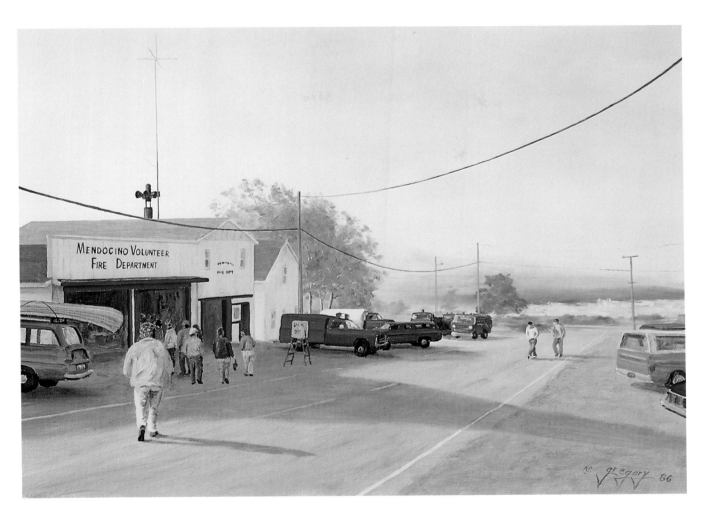

Pancake Breakfast 1986
Oil, 11 x 15 in.

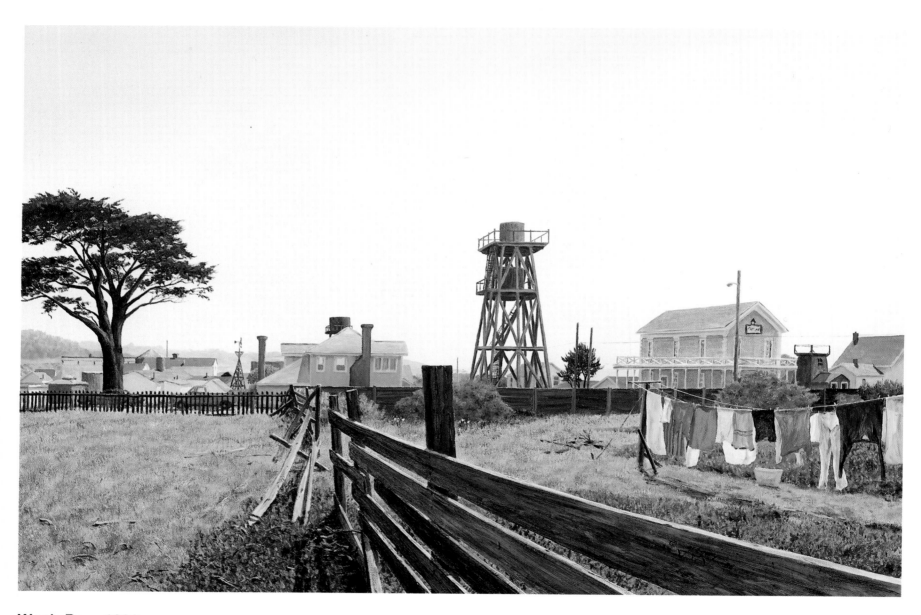

Wash Day 1986
Oil, 20 x 30 in.
Wilmer and Evelyn Zehr

People keep trying to put their finger on what it is that makes Mendocino so special. After all, there are thousands of other rural villages of comparable size and isolation, but few, if any, with the same mystique, the same kind of reputation.

The Bear & Stebbins book, cited earlier, closes with a line entered in the guest book of their Mendocino Historical Research Center: "For some unknown reason we feel at home here."

And another book[1] about Mendocino, co-authored by yours truly and local restaurateur Margaret Fox, quotes a midwestern tourist as saying, "You know, this is one of the very few places in the world where the locals and the tourists do the same things for pleasure." It is a lived-in, comfortable, *alive* place, and if we knew you were coming, we'd be glad to see you, but we might not dust the living room thoroughly or take our wash in from the line. Hope that's OK.

[1] *Cafe Beaujolais* by Margaret Fox & John Bear, published by Ten Speed Press, Berkeley.

The tall yellow building seen above the clothesline (the clothes are *still* hanging out; well we're not going to apologise about that) was built in 1878 as the Odd Fellows Hall. It subsequently passed into the ownership of the local 4-H Club, which has acted as landlord to the present user, an art gallery

If Mendocino has a visual "trademark," for many people it is the tall redwood water towers supported on huge beams hewn from the giant virgin growth redwoods once found around the village. Some of the towers were removed in the name of progress. Modern pump technology has theoretically rendered them obsolete— but it would be hard to convince a tower-owner of this when the electricity has failed (as it often does in winter storms), but the law of gravity is marching along just fine, thank you. Some of the towers have collapsed from the twin vigors of age and neglect and will not be replaced, but at least one new tower has appeared on the horizon in recent years.

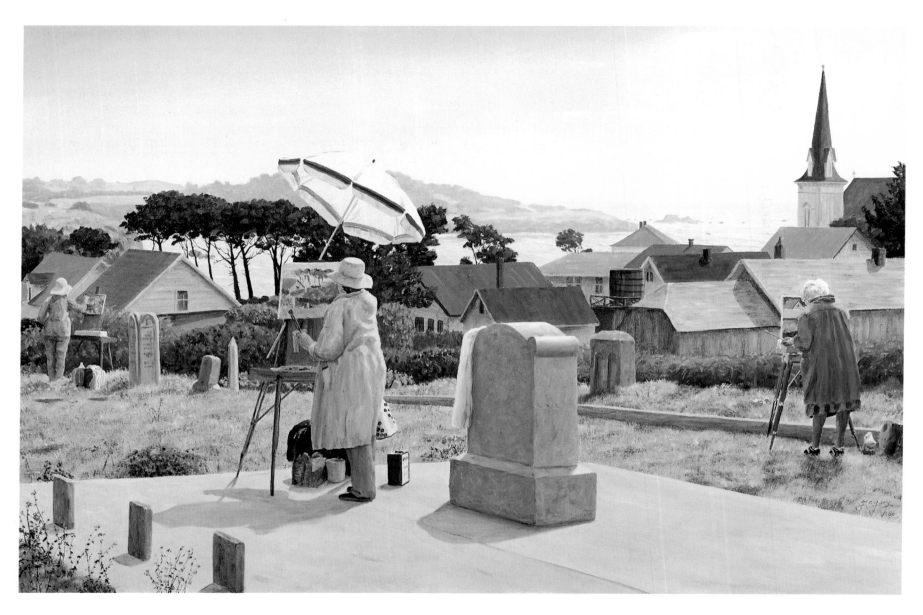

Painting the Town 1986
Oil, 20 x 30 in.
Private Collection

Mendocino is, obviously, supremely paintable. Painters of all ages and skill levels can be found at work almost any day of the year.

While artists first discovered Mendocino in the last century, interest in the arts began flourishing with the establishment of the Mendocino Art Center by William Zacha and his colleagues in the 1960's. The Art Center has grown into a sizeable institution, with an internationally renowned weaving apprenticeship program plus year-round, summer and weekend courses in painting, pottery, textiles, photography, and other forms of art.

The "For Sale" sign is a common fixture around town. Some are due to old-timers (or their estates) whose properties may have appreciated fifty-fold over the years. Others are absentee owners, hoping to make money in the erratic local real estate market. And once in a long while, someone actually decides to leave Mendocino voluntarily, and puts his or her home up for sale.

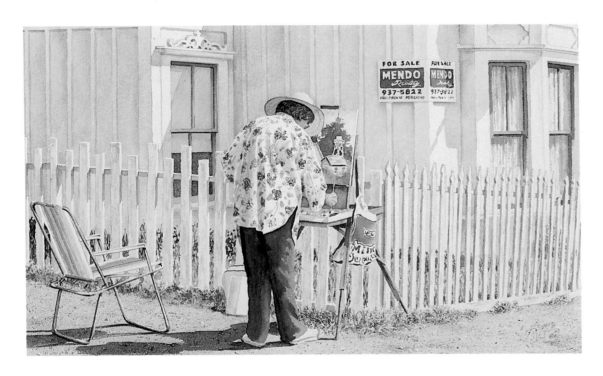

For Sale 1986
Watercolor, 13 x 20 in.

Mendocino is blessed with an unusually good school system. The Middle (Junior High) School, whose marching band performs during the July 4th parade and other celebrations, was honored by the Department of Education in 1986 as one of the outstanding public schools in the United States.

When our family, with three little girls, was ready to move from England back to America in the early 1970's, we wrote to dozens of school districts around the country, asking questions about their facilities, philosophy of education, and enrichment programs. Not only did the one detailed and substantial reply come from Mendocino, but principals in several other districts wrote to say, in effect, 'Don't come here; go to Mendocino. That's what I would do." And so we did and never regretted it. The scenery and tranquility were added bonuses.

Community interest in the schools is erratic. It has always been hard to get people to turn

Puzzle: Can you find a prominent if occasionally controversial newspaper columnist watching the parade?

out for PTA or athletic boosters' club meetings. But when a group of conservative citizens petitioned the school board for the removal of the Grammar School principal (who wore both a beard and a peace symbol), hundreds of people turned out to voice their support of one side or the other. (The principal was retained, but a few years later he was transferred to a non-administrative position.)

This level of community involvement is a healthy sign. When a new superintendent of schools was needed, a committee of teachers, parents, administrators, and townspeople was convened to screen the applications, interview candidates, and make final recommendations to the Board of Trustees.

Mendocino tends to have high quality teachers (as well as other professionals) because it is Mendocino, and so there is heavy competition for the right to be able to work here.

One especially interesting thing about the schools is that they are probably as close to a

classless society as anything Karl Marx envisioned. When our children were invited to the home of friends, there was no way they (or we) could predict in advance whether we would find them living in an oceanfront mansion, a rusting converted schoolbus in the woods, or anything in between. The school district is sparsely populated but immensely large, stretching nearly fifty miles over the hills to the east. Some children spend more than three hours a day on the school bus.

Mendocino High School was dedicated in 1894 in its buildings on the hill overlooking the village and the ocean. Photos of nearly a century of graduating classes adorn its halls. In the 1970's, a small "alternative" high school was started, largely as an outreach to the youth of the area who had dropped out of the regular schools and the system. Over the years, Mendocino Community High School has grown into a full-fledged independent school, although some students (and some faculty) take (and teach) classes at both schools.

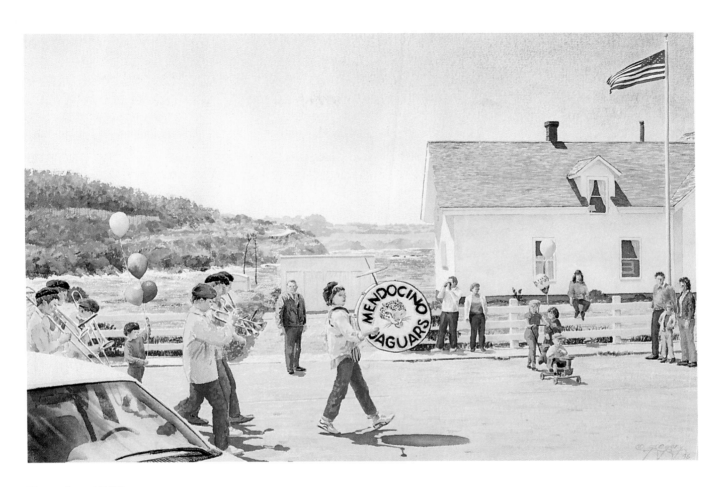

Parade 1986
Watercolor, 14 x 21 in.
Private Collection

International tensions may grow; armies may race across the map; nuclear weapons may orbit in space; but in Mendocino the most powerful emotions seem to be aroused, if we can believe the letters to the editor of our many local periodicals, by things that take place on our streets and, such as they are, sidewalks.

More than a dozen street and sidewalk-oriented causes celêbre have emerged in the last decade: dogs running wild in packs; film makers closing down a street; public restrooms (or the lack thereof); signs on various buildings (too big, too small, too garish); pay phones being vandalized; the deterioration of public trash receptacles; people loitering on the steps of various buildings; putting in or taking out stop signs; animals fouling the footpaths; and the like.

But no two issues seem to have aroused the populace and caused people to choose up sides as much as the matter of skateboards and the matter of street vendors.

To those who use them, a skateboard is (a) a recreational device, (b) a means of transportation, and, for some, (c) a way to assert oneself, terrifying or harrassing people who would dare to use the same stretch of sidewalk.

In the spring and summer of 1986, things came to a head. Some skateboarders were clearly exceeding the limits of safety, good manners, and common sense. Some citizens demanded that all riders be arrested and their boards confiscated. Others brought up the issue of the lack of youth facilities in the area, and at least skateboarding is good exercise and done outdoors and would you rather have these people inside indulging in sex, drugs and rock and roll?

Things got stormy for a while, with the sheriff confiscating skateboards of (depending on whom you listened to) either flagrant abusers or anyone in sight. Finally the Board of Supervisors, who have jurisdiction over the unincorporated part of the county that is the village of Mendocino, passed a compromise measure, limiting both the times and the locations that skateboarders can do their thing. Does this all seem like a rather trivial thing, hardly worth all the time and attention? Perhaps you had to have been there...

Rather more meaty issues were raised in the great Street Artist flap in the late '70s. At the time, there were a small number of artists, sculptors, craftspeople and musicians who displayed their wares or their talents on the public sidewalks. Some merchants and others objected to the noise, the competition, or perhaps the very existence of these people, and after heated debate, the Board of Supervisors passed a hastily-drawn ordinance forbidding the doing of anything on a public sidewalk in expectation of being paid. To preserve the protection of the first amendment, distribution of free literature was expressly permitted.

In order to test this new law, a local troublemaker (well, actually it was the author of this

very book) set up a sidewalk vending table beneath the big clock on Main Street. At this table, free copies of *Hustler* magazine were given away and copies of the Bill of Rights were sold for 5¢.

Under the new law, of course, giving away *Hustler* was perfectly legal, and selling the Bill of Rights was a violation of the law.

The sheriff was informed of these scofflaw activities (Mendocino does not have its own law enforcement, but depends on the county sheriff), and in short order, a deputy arrived to make an arrest.

An enlightened local judge declared the law an abridgement of the freedom of the press, and therefore unconstitutional. The law was thereupon rewritten to permit the sidewalk vending of printed matter only. And the street artists have never returned to the streets of Mendocino.

Pastime 1986
Watercolor, 20 x 14 in.

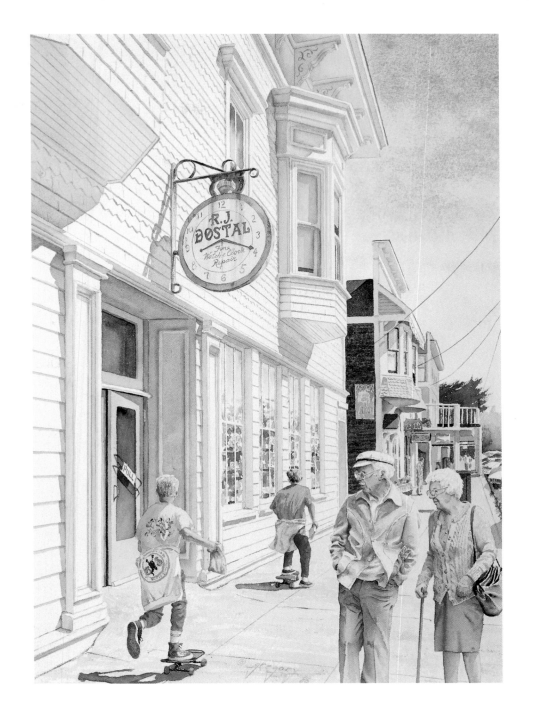

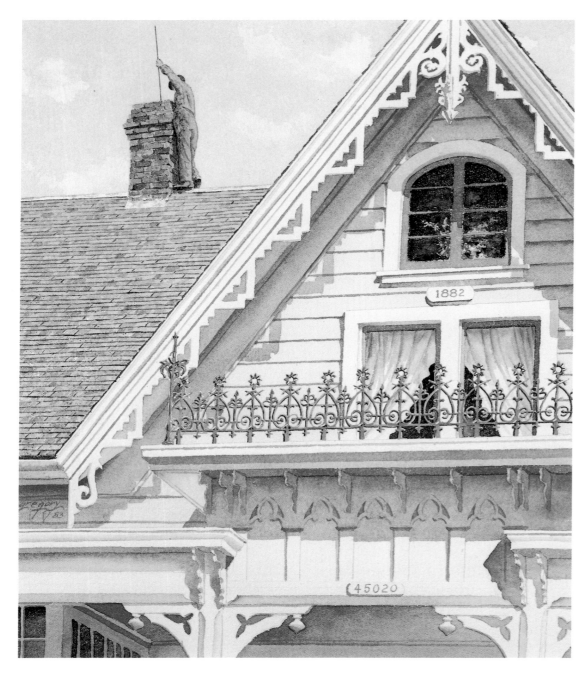

The Mendocino area does not offer much in the way of white collar employment. And yet it has such an appeal to white collar people, many of whom are more than willing to make a rather dramatic career (and collar color) change in order to survive in the country.

And so, among many others, one has been able to find, in and around Mendocino, a former stock broker who sweeps chimneys; a former computer executive who repairs sewing machines; a former NASA official who is a plumber; a former college professor who sells candy; a former publishing executive who drives a bus; and a former naval officer who manufactures ice cream. How many of them would return to their old jobs? Do you see any hands raised?

Chimney Sweep 1983
Watercolor, 16 x 13 in.
Tod Detro

We were once rather proudly showing a European visitor around Mendocino. She was clearly unimpressed. "These may have been nice houses once," she said, "But how could the owners let them get into this condition?" Well, there are two schools of thought with regard to the outside of Mendocino's old buildings: paint them often, or let nature take its course.

Redwood weathers impressively, especially in the cool salt air, turning slowly from reddish brown to grey. And so one finds Mendocino houses and fences that have been allowed to weather, either because that is what the owner wanted, or due to benign neglect.

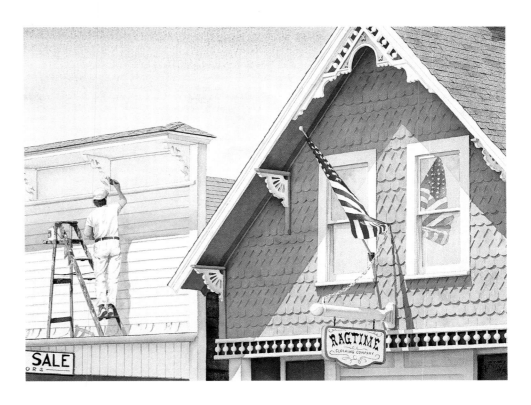

Holiday Painter 1986
Watercolor, 16 x 21 in.
Tony and Vanessa Grant

During one of the recurring battles over whether the proposed remodeling of an old building was "historically accurate" or not, a frustrated landlord complained, "If they really want this town to be historically accurate, they should issue licenses to operate a dozen brothels up and down Main Street."

In its heydey as a lumbering town, Mendocino's population was substantially greater than it is now: upwards of 5,000, many of them single men or men away from their families. To cater to the needs of these men, Mendocino provided twenty or more saloons, and ten or more hotels on Main Street

alone. Some of the hotels were, of course, "hotels" or *hotels.* Once, when I was looking for an office to rent in town, I discovered that the lovely blue building on the right offered 12 or 14 tiny windowless upstairs bedrooms. But with the demand for commercial real estate, even these are now gone.

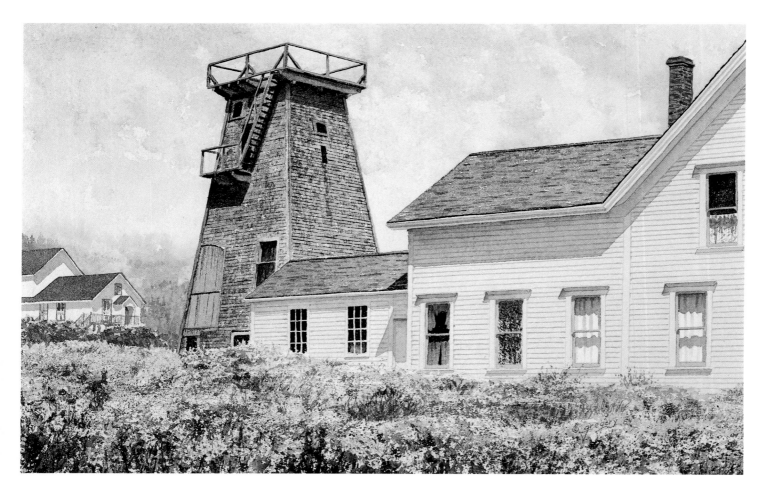

Summer Afternoon 1984
Watercolor, 10 x 15 in.
Staugas-Bray Collection

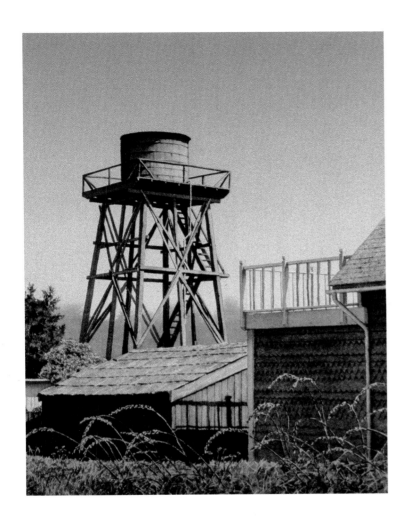

Near Mendosa's 1981
Watercolor, 18 x 13 in.
Private Collection

Most city people never give a thought to their water: it is what comes out the faucet whenever you want it. But in Mendocino, it is a precious commodity. The well on our land was drilled at the height of a long drought. The engineer came out with his geological maps, his soil test kit and his assorted scientific instruments. After a bit, he said, "I think we'll drill right here—but first let me check it with the divining rod." We don't ask questions; we're just grateful that a plentiful supply was found at a depth of fifty feet.

Behind the Sea Gull 1983
Watercolor, 8 x 12 in.
Byron and Pat Scott

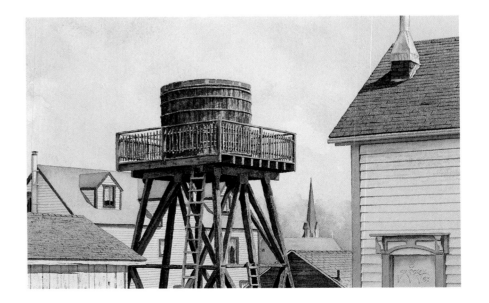

It is not uncommon for those professional people who "escaped" from the big city (usually San Francisco) to Mendocino to be regarded by their urban friends with a mixture of awe ("By golly you really *did* it"), pity ("But you're so far from the nearest opera or symphony or museum") and envy.

Significant numbers of city people harbor the fantasy that one day they will sell everything, move to a beautiful and relatively unspoiled spot, and put their business, managerial, cooking, manufacturing or entrepreneurial skills to work by acquiring or starting a small business.

Some of these people actually do it, and some of those actually succeed, although rarely beyond their wildest dreams. One common problem is that most tourists come to Mendocino during the tourist season, and their business musings are beguiled by seeing the crowds on the streets, the lines waiting to get into restaurants, the "No Vacancy" signs in profusion on the doors of bed and breakfast inns. These people should be required by law to spend a week in Mendocino during a cold and dreary February rainstorm, before signing any contracts or checks.

Over the past ten or twelve years, we have seen more than 100 new businesses start up: shoe stores, galleries, boutiques, ice cream parlors, pizza parlors, computer stores. And within a year or two, seventy percent of them were gone— undercapitalized and unable to survive the rigors of the long grey winter.

On the other hand, dozens of new enterprises, well conceived and well-managed *have* succeeded, filling needs of residents, visitors, or in many cases, a distant clientele. As one successful mail order entrepreneur put it, "Businesses like mine bring in dollars without bringing in people, and that's just what this area needs."

In the hills, valleys and woods around Mendocino, people are actively producing or acquiring and selling by mail everything from books to biofeedback equipment, Italian pastries to rare musical instruments, hand dipped chocolates to architectural ornaments.

There is always a living to be made in Mendocino by creative people willing to work hard. As Margaret Fox put it, "reflect deeply and long on whether you would rather live in the city, breathe smog, triple lock your door every night, and make a lot of money; or live in Mendocino, breathe air, rarely lock anything, and make a good deal less money. There are no simple answers, and the only foolish answers are those that are made in haste without considering all the ramifications."

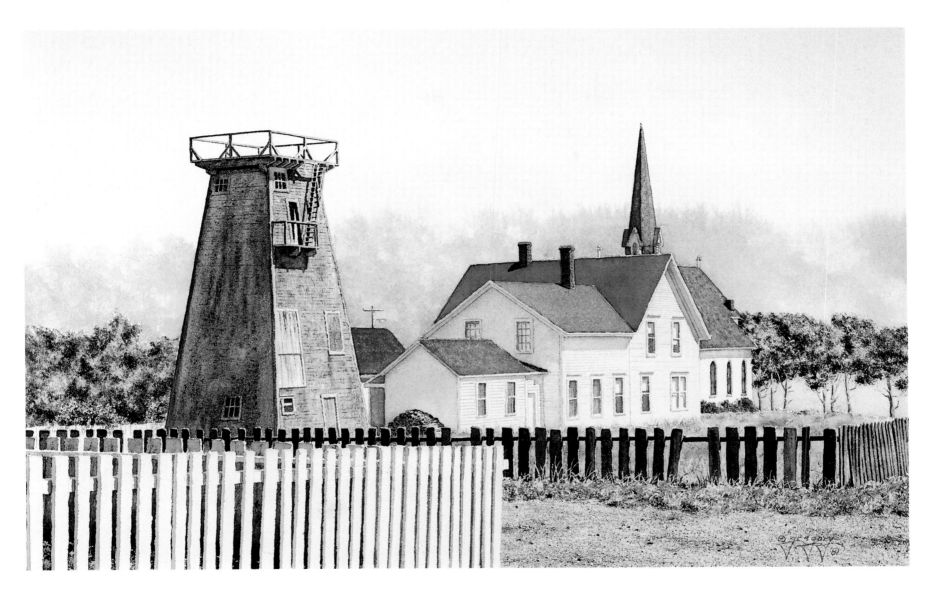

Albion and Howard 1981
Watercolor, 14 x 21 in.
Byron and Pat Scott

William Heeser came to Mendocino in 1857—one of the few early settlers who did not come because of the lumber industry. He brought a nest egg with him, and used it to buy 200 acres of land—almost the entire peninsula of Mendocino— from the Kelley family for $30 an acre.

Heeser subdivided a small portion of his land into 1/14th of an acre parcels and sold them to local working men for $40 and up.

After serving terms as judge and county supervisor, and after establishing two banks, Heeser, in the same year (1877) became the father of a son, August, and of a newspaper, the *Beacon.*

William and, later, August ran the *Beacon* for nearly three quarters of a century. In his seventies, August finally married his childhood sweetheart, Edith Nichols who had left Mendocino to make her career in the world of music in far-off New York City.

Ownership of the weekly news-paper remained in the Heeser family for 99 years, when the last individual owner, a cousin by marriage, sold it to a southern California-based chain of newspapers.

For many in Mendocino, it was as if an old friend—one you kind of took for granted—had suddenly died. The local anguish was compounded when the new owners destroyed an historic collection of old photographic plates, junked the old but functional printing equipment, and the well-respected editor either was fired or quit, depending on whom one listened to.

The concern crossed all boundaries of age, job, or political preference, and many people were saying "We've got to do something."

Meetings of concerned local citizens were called to discuss the possibility of starting a new paper or buying back the *Beacon.* They were attended by local members of the John Birch Society, the I.W.W. (alive and well in Albion, just south of Mendocino), and people of every possible set of viewpoints in between.

Finally, the new owner of the the paper flew in to assure us that nothing would be changed. Anyway, with the passage of time, high dudgeon turned to low dudgeon and eventually no dudgeon at all. When the southern California chain sold "our" *Beacon* to an Arkansas publishing conglomerate a few years ago, most people hardly noticed. The Beacon Building, built in 1872, still contains the paper's business and editorial office, although the production area has been converted into offices and shops.

Besides the *Beacon* and its sister paper (the *Advocate News* published in Fort Bragg, ten miles to the north), the community supports (or has, at times supported) a surprising number of publications of varying frequency and quality: the *Big River News, North Coast News, Ridge Review, Commentary, New Settler, Arts & Entertainment, Contact,* and at least half a dozen others.

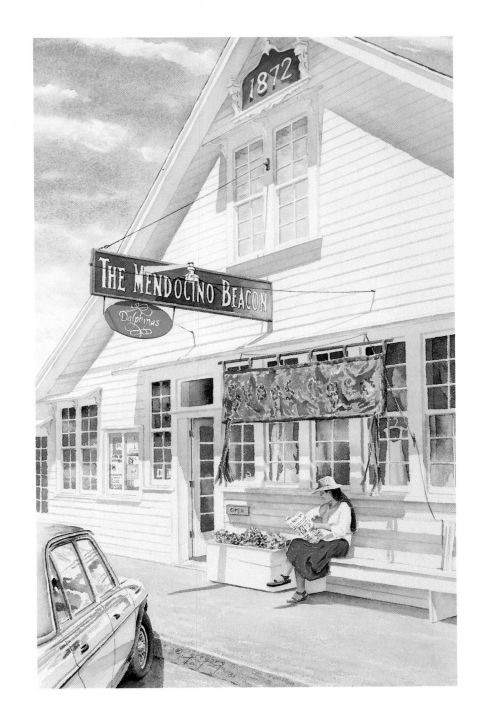

Wednesday Morning 1986
Watercolor, 22 x 14 in.

This is one of the most common views in Mendocino, because it is what you see when you are hanging out around the post office.

Because there is no home or business delivery of mail in the village, Picking Up Your Mail is the social highlight of the day for a good many people. You are bound to see anywhere from three to thirty people you know, and can spend (waste?) as much of the morning as you elect discussing the important issues of the moment.

Inevitably home delivery will come to Mendocino one day, and a significant part of village life will have gone the way of "progress." I, for one, would refuse to install a mailbox.

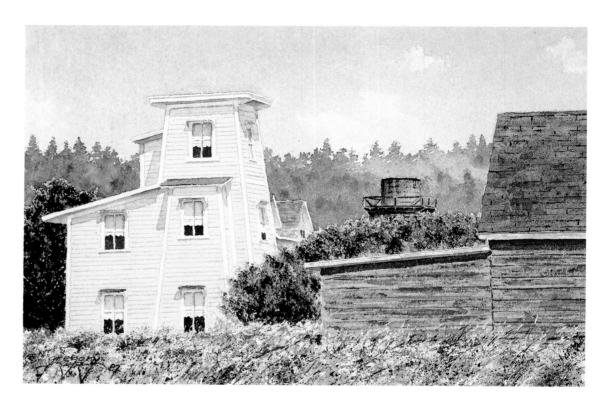

View From The Post Office 1982
Watercolor, 6 x 9 in.
Mr. and Mrs. Peter Keim

One of the unexpected things about Mendocino weather is that you can often see it before it gets there. Weather fronts move in from the west or the northwest. It is not uncommon, on a bright and sunny day, to look west, and there, out over the ocean is a huge fog bank or even a rainstorm, poised to move in over the town. There have been times when, for a brief period, there was a heavy rainstorm on our back deck and it was clear and pleasant in front of the house.

As with many rural communities, weather is an important factor in the life of Mendocino—perhaps even more so because of the geographical isolation. There are only three roads into Mendocino—one from the north, one from the east, and one from the south—and there have been times when all three were closed by fallen trees, flooding, or landslides. And flooding doesn't just mean a few puddles on the road. On Highway 128, leading south toward San Francisco, there used to be a water mark sign twelve feet up a pole, show-

where the water level had gotten to in one particular storm. The sign is no longer there; it was washed away in a subsequent flood.

Most homes are well-stocked with candles or lanterns and a food supply. People don't complain much when the power goes off or the phones fail; it is simply a part of Mendocino life.

Evening Fog 1985
Oil, 9 x 12 in.
Private Collection

Mendocino, for most intents and purposes, does not exist.

That is not a metaphysical remark, but a legal one. Mendocino has never incorporated as a city; it is simply a part of Mendocino County. Its laws are passed and administered by the county supervisors (a 90-minute drive away in Ukiah). Its police force is the county sheriff and his deputies.

For many people in Mendocino that's just fine. The system works and they do not wish to tamper with it. For others it is unconscionable that five supervisors, only one of whom is from Mendocino, should make and enforce their laws. Some claim that only a small percentage of the the taxes sent "over the hill" to Ukiah are returned in the way of public and social services.

For well over 100 years, the subject of incorporation has been considered. Every two to ten years, it becomes a heated public issue, and occasionally finds its way onto the ballot.

In 1882, the matter arose and virtually cleaved the town in two. Heated arguments, fisticuffs, and a barrage of letters to the editor. The business community seemed pretty well evenly divided. Some said "Let us gain control of our destiny." Others said, "We have enough government already." But in the end, nothing came of it.

Exactly 100 years later, the matter of incorporation finally made it onto the ballot. After months of debate, the several hundred registered voters went to the polls. The verdict came in: incorporation wins by three votes. Jubilation in one camp, despair in the other. But wait! A few more absentee ballots were discovered, and now incorporation *loses* by two votes. Despair turns to jubilation, and jubilation turns to a vow to bring the matter up yet again one of these even-numbered years.

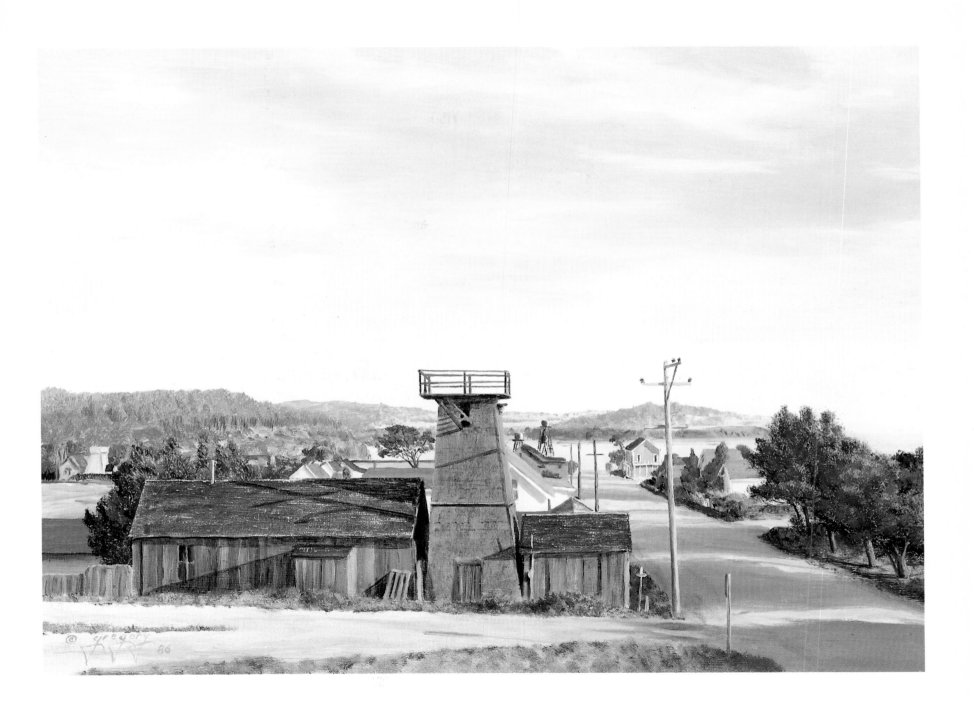

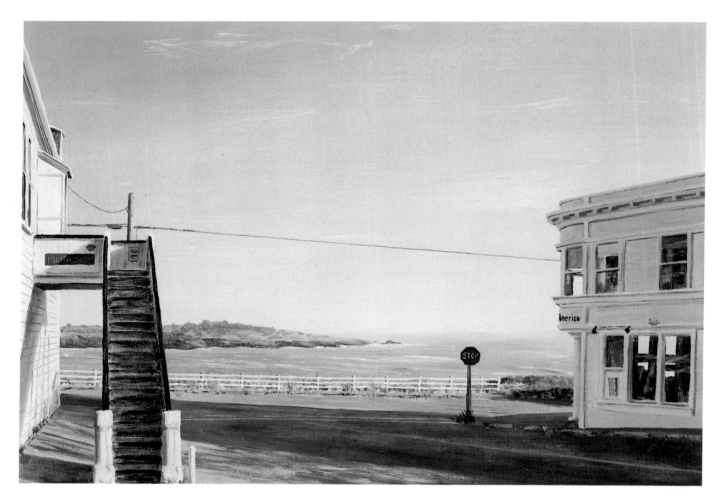

Six P. M. 1985
Oil, 9 x 12 in.
Mr. and Mrs. Gary Entwistle

The corner of Main and Kasten —the old Jarvis & Nichols Store (now a general commercial building) on the left and the old Bank of Commerce (now Bank of America) building on the right—is also known as "Jack's Corner" because that is where the gentleman who writes a newspaper column of that name has been known to "hang out" looking for items.

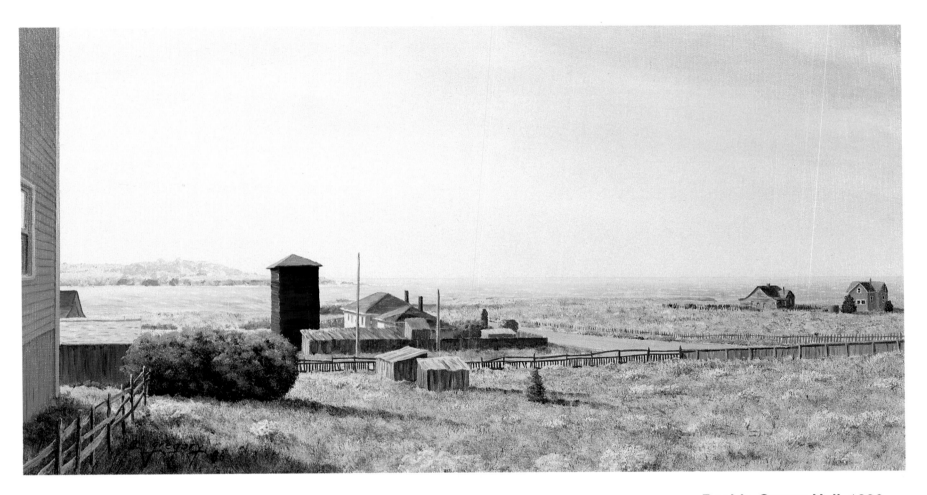

Beside Crown Hall 1986
Oil, 9 x 17 in.
Private Collection

In the Spring and Fall, great whales can be seen spouting off the Mendocino peninsula as they migrate between Alaska and their spawning grounds in Mexico. In the mid-1970's, local sculptor Byrd Baker launched a mighty campaign to "save God's whales" from the harpoons of Russian and Japanese whaling boats, some of which plied their bloody trade as close as 12 miles from the coast. The Mendocino Whale War lasted several years, and involved (among much else) a local boycott of Japanese products, festivals, and a dramatic confrontation in which Baker and a few colleagues positioned themselves, in a small rubber boat, between a huge Russian whaling ship and a pod of whales. The Russians, thankfully, backed down.

One of the lighter moments, and good for much publicity, was a broadcast plea, in Russian, by a local woman calling herself "Mendocino Rose" urging the Russian sailors to abandon ship and come to the Mendocino headlands where she would be waiting for them with a "Russian defectors' kit" (blue jeans, ball point pens, cigarettes and a ticket to Disneyland). As far as is known, no Russians defected, but the Mendocino Whale War clearly had an impact on the eventual decision to end the killing of whales in the Pacific Ocean.

Approaching Fog 1985
Oil, 12 x 16 in.
Wayne and Lynne Marschall

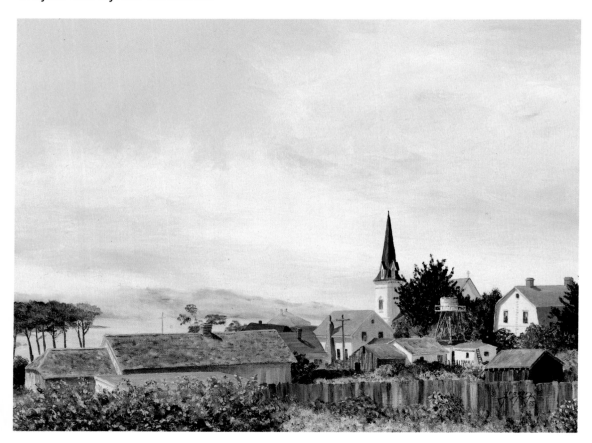

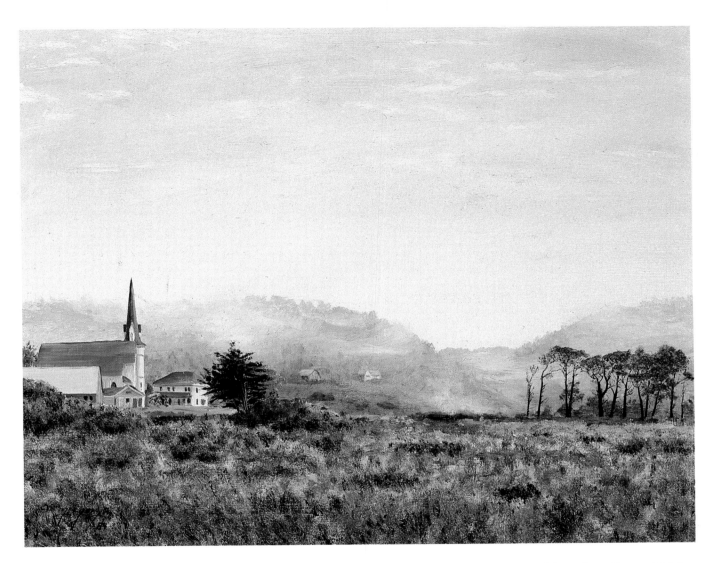

Morning Fog 1984
Oil, 11 x 14 in.
David and Tia Rosen

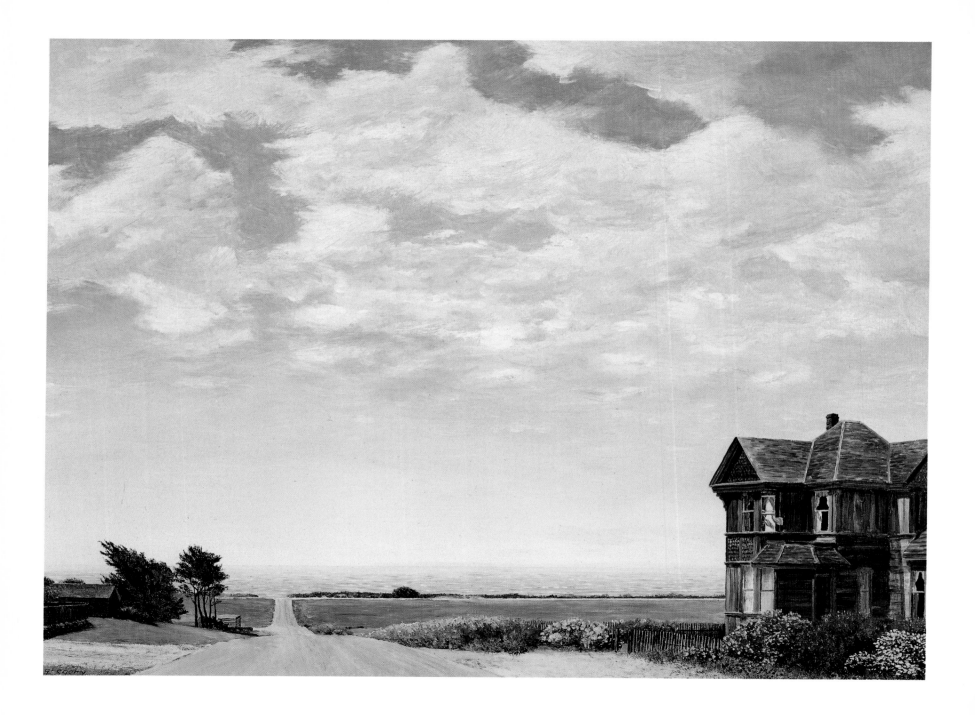

70 MENDOCINO

Silhouettes 1986
Oil, 11 x 15 in.
Tom and Michelle Gregory

The Mendocino headlands are beautiful, and they are treacherous—all the more dangerous because they appear so calm and peaceful. Just as approximately one wave out of nine is larger than those that have come before, so too is one wave out of every several hundred thousand a killer: a huge and utterly unexpected wave roaring out of a relatively calm sea. Every few months, when one of those hits, inevitably people somewhere along the coast are swept away. The oft-repeated advice, "Don't turn your back on the ocean" is not just a slogan; it must be a way of life.

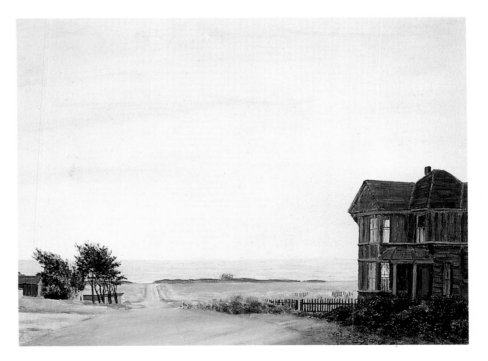

Windy Day 1985
Oil, 18 x 24 in.
Roseanne Henry

Headlands at Sunset 1984
Oil, 8 x 10 in.
Evelyn and James Lee

Mendocino: From This Side of the Grave 1982
Watercolor, 16 x 29 in.
John W. Kessel

Some of the loveliest land in Mendocino is given over to cemeteries. There are cemeteries for Catholics, for Protestants, for the Chinese, and for miscellaneous people.

There are apparently not many remains in the Chinese cemetery, for the Chinese of Mendocino were isolated from the community in death as they were in life. Many older Chinese went home to China to die; otherwise, their remains were often shipped there for burial.

The Chinese were a major presence in northern California in the years following the discovery of gold. Many came to seek their fortunes in the gold fields and stayed to work as cooks and laborers in the mines and the mills, or to build the railroads. Many opened shops and laundries; some went into farming. But they rare-ly became a part of the community, whether by their choice or by edict. By the late 1800's there were more than 200 Chinese in Mendocino, including dozens of children, but the children were not welcome in the public schools. Finally a private tuition-supported one-room Chinese school was established in 1889 which, as the *Beacon* reported "solves the vexed question of admitting Chinese children into our public school, over which there has been considerable trouble here."

Mendocino is the site of one of only three Joss Houses, or Chinese temples remaining in California. It was built in the early 1850's by a group including "Joe" Lee, whose junk sailed from China and put ashore just north of Mendocino. The Joss House is owned by some of Lee's descendants, the last Chinese family in Mendocino.

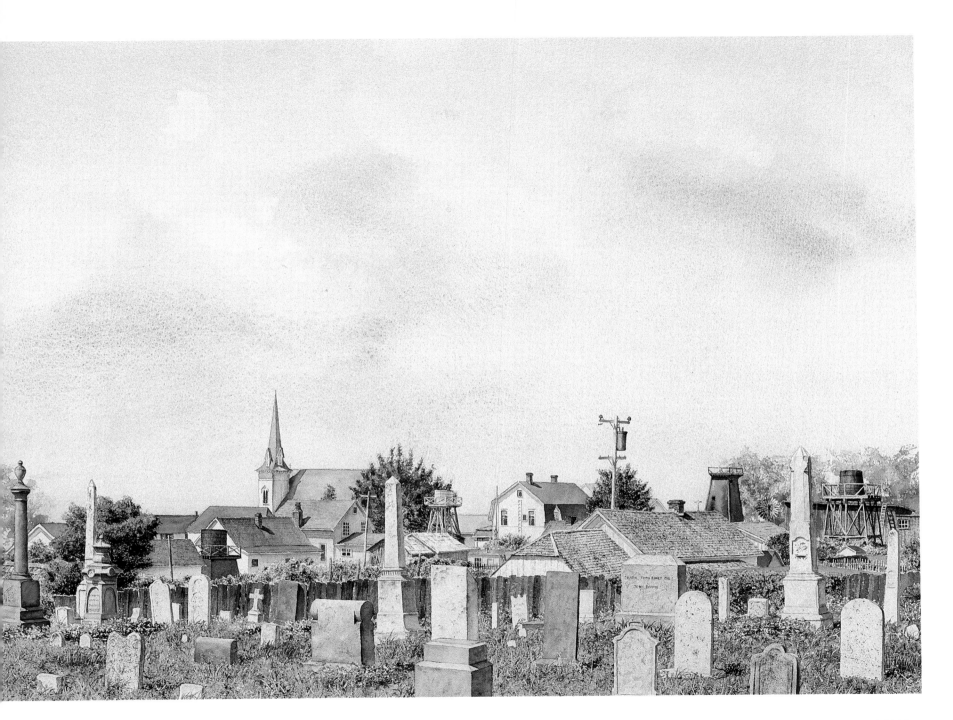

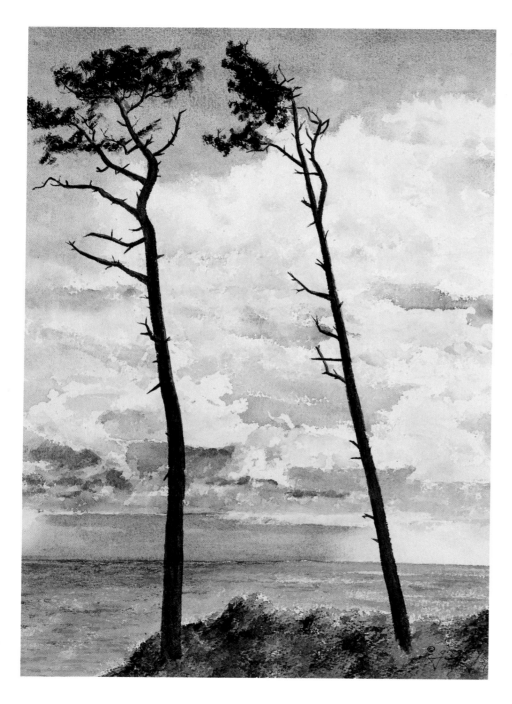

Ocean Storm 1979
Watercolor, 18 x 13 in.
Mike and Sally Gregory

Abalone used to be plentiful off the Mendocino coast, and there were those who said that the best time to find them was just before a storm.

But with abalone meat now selling for four times the price of the best steak, and the iridescent shells more in demand for jewelry and crafts, poaching has become a major problem. You are allowed to collect no more than four abalone a day, and they must be large ones: at least seven inches across. Even though rangers with powerful binoculars patrol the cliffs and the headlands, and even though the penalties can be extremely severe, more and more people seem willing to take the chance.

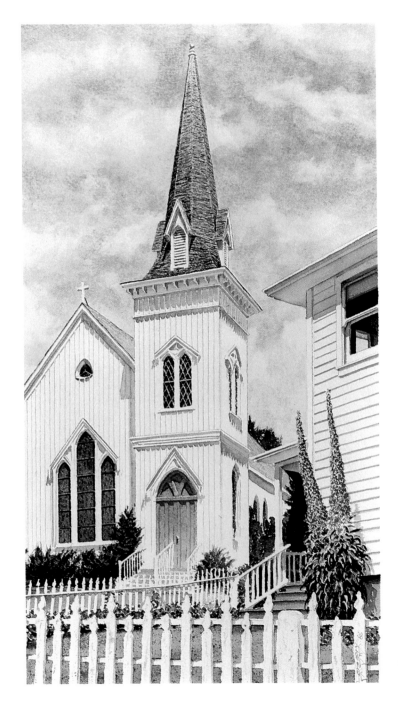

California Historical Landmark number 714, the Mendocino Presbyterian Church, was built of locally cut and milled redwood in 1868 at the rather substantial (for then) cost of $7,000—more than William Heeser had paid William Kelley for land representing more than 90% of the Mendocino peninsula.

Many visitors have deduced that the reason the front of the church faces away from Main Street is so that it can look directly out over the beauty of Mendocino Bay. This is a charming notion, but the simple truth of the matter is that the Old Coast Road used to pass on the other side of the church, right in front of the front door. When the bypass of Mendocino was built (the only 4-lane stretch in 200 miles of Highway One), the Old Coast Road was no more.

Presbyterian Church 1986
Watercolor, 20 x 11 in.

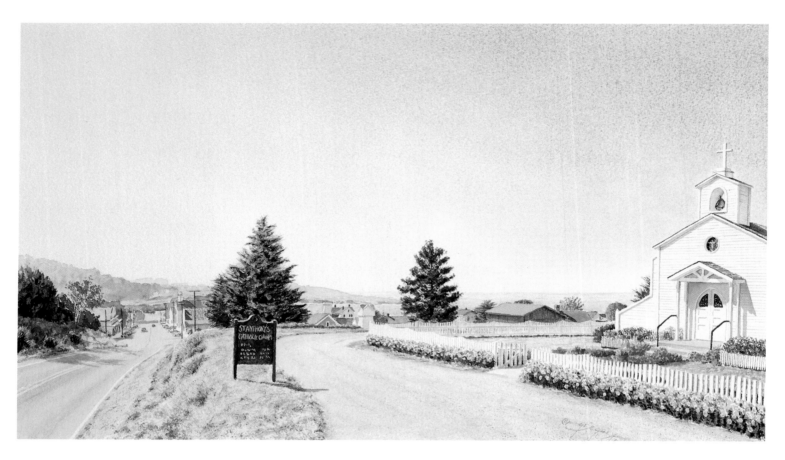

St. Anthony's 1986
Watercolor, 12 x 21 in.

There has been a Catholic church in Mendocino since 1864. St. Anthony's was built in 1930 to replace a church and seminary that had burned.

The church is built on a street whose name is one of those phenomena that so intrigue and frustrate historical researchers. On modern-day maps it is listed as Cahto Street, but in the old map books in the county seat at Ukiah it is shown as "Catho" Street. Can it just be a coincidence that "Catho" Street led to the Catholic church? Was that its full name or just an abbreviation?

Was it changed because of some anti-Catholic sentiment, or because of a printer's error or some other reason, if indeed it was changed at all? These are questions to ponder as you sit in the weekly bingo game at the church hall adjoining St. Anthony's church.

The old barn downhill from the church is known as the Priest's Barn even though it is now privately owned. Once, after a fire, the high school was temporarily housed in this barn.

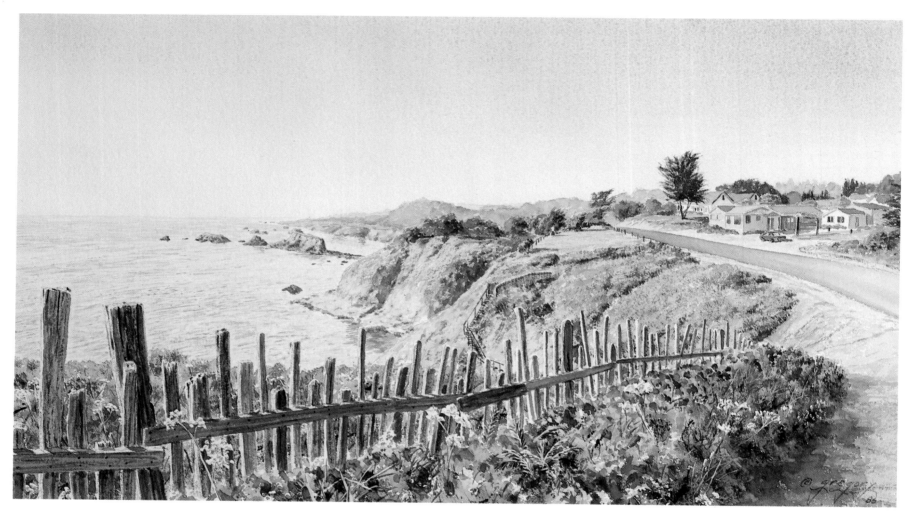

Sea Rocks 1986
Oil, 12 x 21 in.

Heading north from Mendocino on Lansing Street, one comes first to a small motel that was, for decades, advertised only in *The Progressive*, a Wisconsin-based political magazine. Under new owners, it has been "inn-ified" and the clientele comes from more usual sources.

Along the road north to Caspar is found the dreaded Scotch broom. Just north of Mendocino is Russian Gulch State Park, one of three oceanfront state parks in the vicinity of Mendocino. The Russians were quite active along the northern California coast in the middle of the 19th century. When "Seward's Folly" acquired Alaska from the Russians in 1867, their presence in North America declined quickly. Their memory continues only in Fort Ross (a restored Russian fort and church 70 miles south of Mendocino), and in occasional place names along the Mendocino coast.

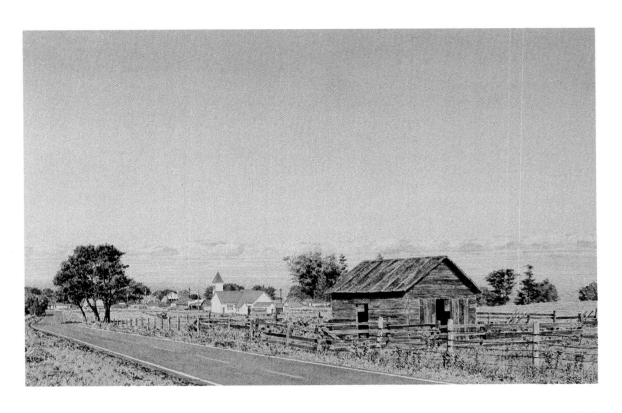

Road to Caspar 1984
Watercolor, 14 x 21 in.

Noyo Harbor lies about eight miles north of Mendocino and a mile south of Fort Bragg. It is the home of a sizeable commercial fishing fleet, a small shipbuilding industry, several fish processing plants, a coffee-roasting factory, and some very good fresh fish restaurants.

Fishing is one of the three major legal industries along the Mendocino coast. The others are lumber and tourism. Each in its own way has had its share of controvery and of problems.

The fishing industry is substantially depressed from its position a decade or two ago. There simply aren't as many salmon, shrimp, crabs, etc. as there used to be. Some blame foreign competition in the offshore waters, or pollution of the streams and rivers with debris from the lumber industry, or the failure of the government to maintain price supports, or over-fishing the waters. It may have to do with any or all of these or even a natural cyclical phenomenon. Some find it ironic, but it is in fact completely logical, that the main fund-rais-er for the Salmon Restoration fund is the annual "World's Largest Salmon Barbecue" held at Noyo every Fourth of July weekend

In the heyday of the lumber industry, every village along the coast had its own mill. The economics all made sense: the huge redwood trees were on one side of the mill and the docks for the lumber-carrying ships were on the other side. As time passed, the logs had to be brought longer and longer distances (as anyone driving into or out of Mendocino behind a huge log or lumber truck can attest). One by one, the mills shut down. Only the mill at Fort Bragg remains along the Mendocino coast, and even the future of that is clouded.

In physics, the Heisenberg principle says that it is impossible to measure tiny particles with accuracy because the very act of trying to measure them changes the size of the things you are trying to measure. There is a kind of Heisenberg Principle operating in tourism as well. The more successful you are in promoting tourism and growth in a region, the more you ultimately change the very things that bring people to the region in the first place.

It is wonderful to have enough people, residents and visitors, to be able to support good restaurants, theater groups, a choice of health care professionals, good schools, satisfactory roads, and so forth. Too few people and you don't have these things. But too many people and lines grow longer, the classrooms overcrowded, the roads clogged, the parking spaces harder to find, the water supply depleted, the social services overburdened.

There is a precarious middle position between feast and famine, and it is nearly impossible to get people to agree on just what it is. Expand the airport? Ban new commercial construction? Build a convention center? Restrict the number of "bed and breakfast" conversions? These are some of the issues coastal people have been wrestling with.

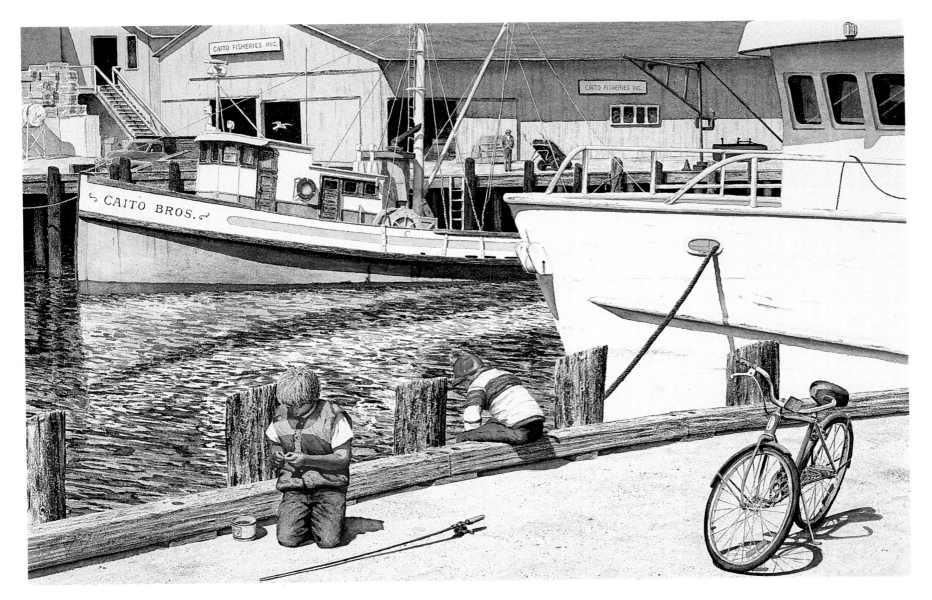

Brothers 1984
Watercolor, 14 x 22 in.
Dale Rempert

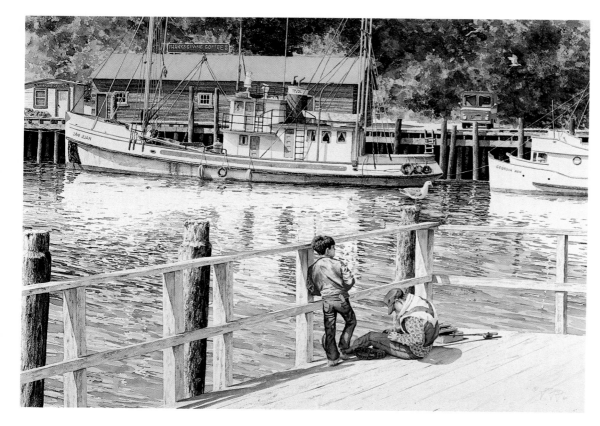

Company at Noyo 1984
Watercolor, 21 x 29 in.

The wooden building across the Noyo River from the two fisherman and their feathered friend is one of the few coffee-roasting factories in northern California. When the wind is right, splendid odors even reach the cars crossing the main highway bridge over Noyo harbor—a distinct improvement over the fish processing factories. Other unique aspects of the Noyo harbor area include a restaurant featuring shrimp wonton, and another offering 1 1/2-pound hamburgers.

Noyo harbor is primarily a place where boats are moored, but once a low-budget film company came to Noyo to make what they declared would be a serious science fiction-horror film. The plot dealt with an experiment to create a new breed of salmon at the salmon-breeding station near Fort Bragg. But something goes wrong, resulting in the creation of half-man half-salmon creatures who rise out of the Noyo River to chase after local women with whom they wish to mate. Many local people had roles in this extravaganza, but it turned out to be so dreadful, the producers ended up declaring that it really was a spoof after all. It lasted about three days in the movie theaters of America, but you can still rent copies of *Humanoids from the Deep* at your local video store, probably because of the scenes of half-man half-salmon monsters chasing half-naked ladies around the beach.

Blue Boat 1981
Watercolor, 15 x 22 in.
Private Collection

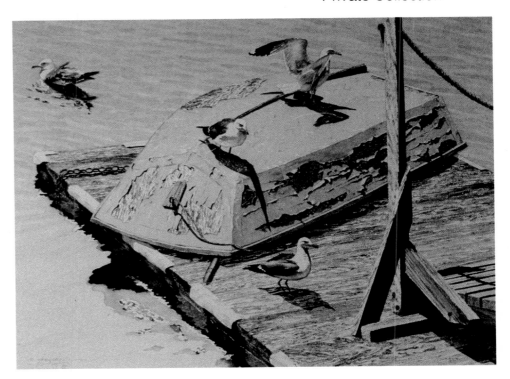

South of Mendocino, State Highway One meanders for nearly 150 miles, through Little River, Albion, Elk, Gualala, Point Arena, Manchester, Fort Ross, Jenner, and other tiny coastal towns, finally ending up at the Golden Gate Bridge.

Along the way, there are farms and sheep ranches, but there is not a single fast food franchise, giant water slide, fern bar, miniature golf course, discount outlet, video arcade, wax museum, or drive-through *anything.*

South of Mendocino 1981
Watercolor, 6 x 12 in.
Jack and Beatrice Waid

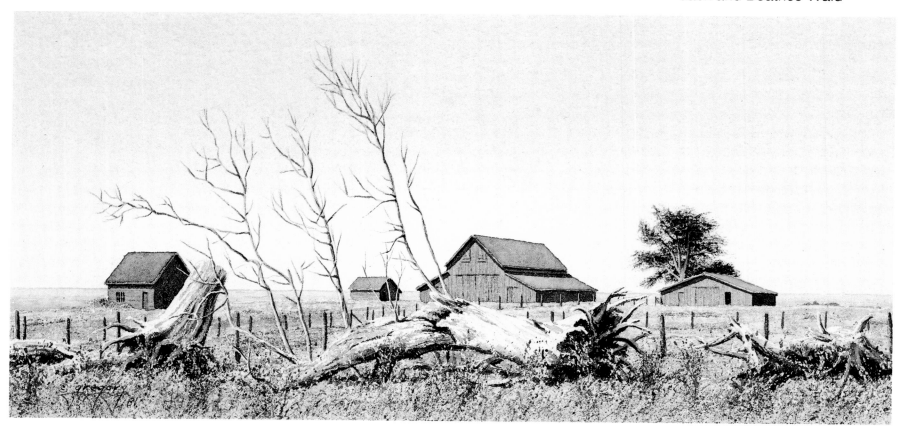

The Little River Inn, two miles south of Mendocino, was originally built as a private home in the 19th century, but it was turned into an inn many years ago, and has been expanded several times since.. To ensure that the Inn would always have an adequate water supply, its owners, in the early days, constructed an elaborate series of ponds and aqueducts stretching several miles inland along the Airport Road. Another half dozen inns, all former homes, can be found along Highway One in Little River.

The airport serving Mendocino consists of a small shed and a huge runway capable of handling large four engine planes. The reason for this is that during World War II, the need was felt for "escape" airports where large military planes could land in case runways nearer to civilization were bombed.

Every few years, someone tries to offer commercial air service to Mendocino, but it just doesn't work. The weather is too unreliable along the coast. Once I booked passage on the inaugu-

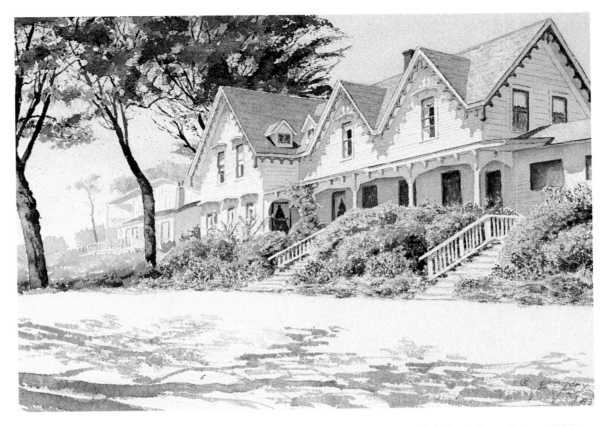

Little River Inn 1983
Watercolor, 10 x 14 in.
Private Collection

ral flight of a new commercial service. At 6 a.m. the phone rang. "This is the airline," a voice said. "We're in San Francisco. Would you mind going outside and telling us how the weather is, so we can decide whether to fly in." I wonder if TWA got its start that way?

When we first moved to Mendocino, it was to an oceanfront house just south of Little River. The house was in a former quarry, whence the rock needed to build the County Airport had been scooped. The house was built right at the edge of the cliff, and there was a fifty-foot drop down to the crashing surf. No fences; it would have spoiled the view. In retrospect this was not the place to move with three under-ten children, a nervous mother-in-law, and a dog that may have had fewer neurons in his brain than a door stop. So the first day, my wife, the girls and I crawled on our bellies to the very edge of the cliff and peered over. "There," my wife said, "Now you've done it. Never do it again." They didn't. We still have three daughters. And the dog? Well, there was the remnant of a tree, clinging to the edge of the cliff, as depicted over there on the right. Samwise (the dog) discovered that this tree was of a perfect height and configuration to scratch his back. And so regularly we would glance out the side window to see this crazy animal, often balanced on three legs, scrunched up under the tree remnant, vibrating wildly, perhaps three inches from his doom. Did he survive, I hear you asking. Well, five years later, when we moved to the house we had built in Mendocino, we observed that old Samwise had actually burnished the bottom of the tree remnant smooth (what will some archaeologist make of *that* in a thousand years?), and he was going strong, as were we all (except the aforementioned mother-in-law, who had developed an ulcerous condition and moved to the safety of downtown Fort Bragg).

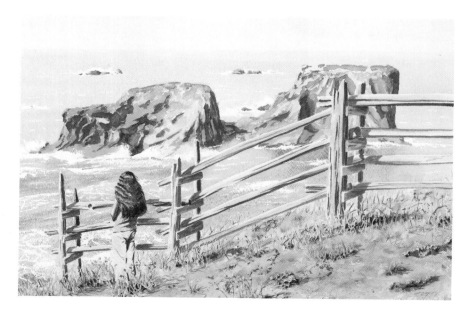

Georgia-Ann 1978
Watercolor, 12 x 18 in.
Artist's Collection

Cliffhanger 1979
Watercolor, 21 x 29 in.
John Donnelly

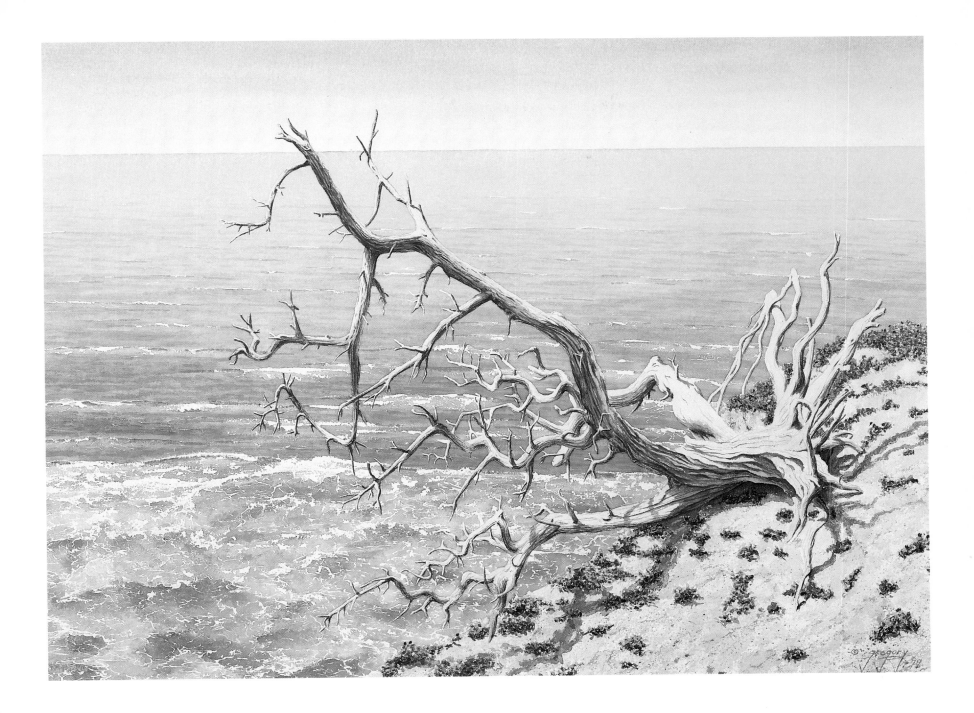

MENDOCINO 87

Summer Fog 1982
Watercolor, 12 x 21 in.
Maura Harper

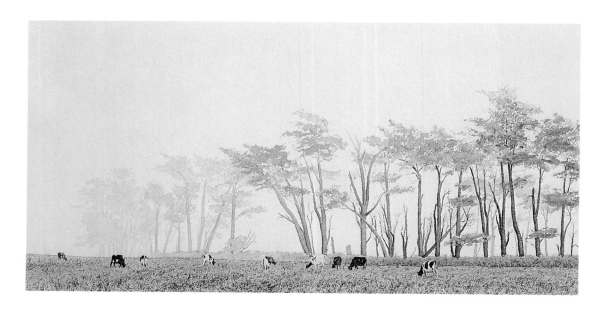

Heritage House is an elegant array of ocean-view cottages south of downtown Little River (population under 500). It is quite possibly the only place within 50 miles of Mendocino with a dress code. The play *Same Time, Next Year* was written with Heritage House in mind, and when the movie was made, it seemed only proper that it be filmed there (plus one tearful scene at the County Airport).

A final word about Little River. Its official name is one word, *Littleriver,* but no one except the postmaster seems to know this, or if they do, they certainly don't care. Even highway signs have it as two words. But then for years the highway signs just north of Mendocino directed one to "Casper." Casper is in Wyoming; Caspar is what they meant. So what? Well, as I said earlier, we tend to worry about little things in Mendocino.

A final word about Mendocino. Words and pictures cannot really do it justice, although David's paintings come as close as anything I've seen. If you have not been, put it on your list; you will not be sorry. If you have been, or better still if you are there, we hope these images will have helped you to look at things anew and to rejoice that you are the one in five million souls privileged to be in this place. Thank you.

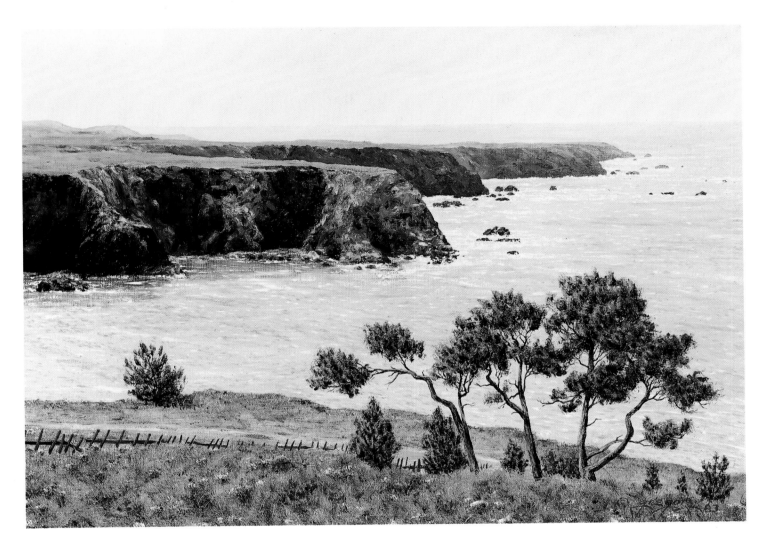

View from Heritage House 1983
Oil, 9 x 13 in.
Private Collection

More about the Village of Mendocino
(and more about this book)

Getting Around
the Village of Mendocino

There are only 21 street names in all of Mendocino, so you'd think we would know them all. A tourist once asked to be directed to Carlson Street and four of us, representing over 100 person-years of living in Mendocino, had no idea where it was. But then they identified the family they were seeking, and of course all of us were instantly able to provide detailed directions.

* * * * * * * *

Just in case you might want to locate the sites of some of the paintings you have seen in this book we have provided a map (see facing page) and the following list.

O indicates direction of view

The Ruth Carlson Gallery where you can see more paintings by David Gregory

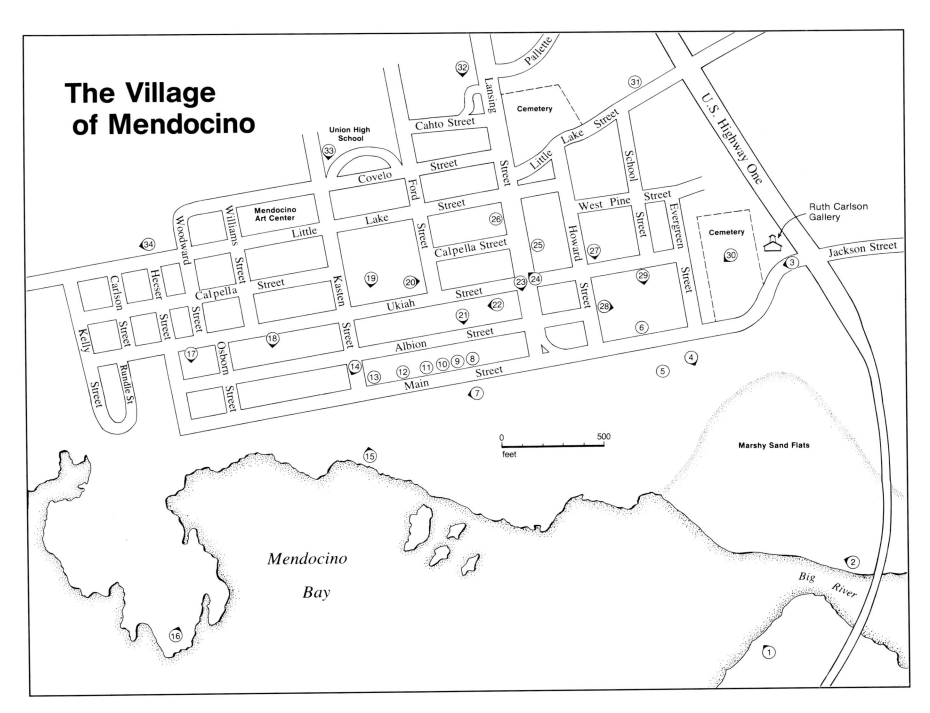

The Village
of Mendocino

Union High School

Mendocino Art Center

Ruth Carlson Gallery

Cemetery

Cemetery

Marshy Sand Flats

Mendocino

Bay

Big River

Pallette

Lansing Street

Cahto Street

Covelo Street

Ford Street

Little Lake Street

Lake Street

Calpella Street

Little Street

Calpella Street

Kasten Street

Ukiah Street

Albion Street

Main Street

Williams Street

Woodward

Heeser Street

Carlson Street

Kelly Street

Rundle St

Osborn Street

School Street

West Pine Street

Howard Street

Evergreen Street

Jackson Street

U.S. Highway One

0 500
feet

Getting to Mendocino

If you are among those who haven't yet visited Mendocino this map of the Northern California coast should help you get there.

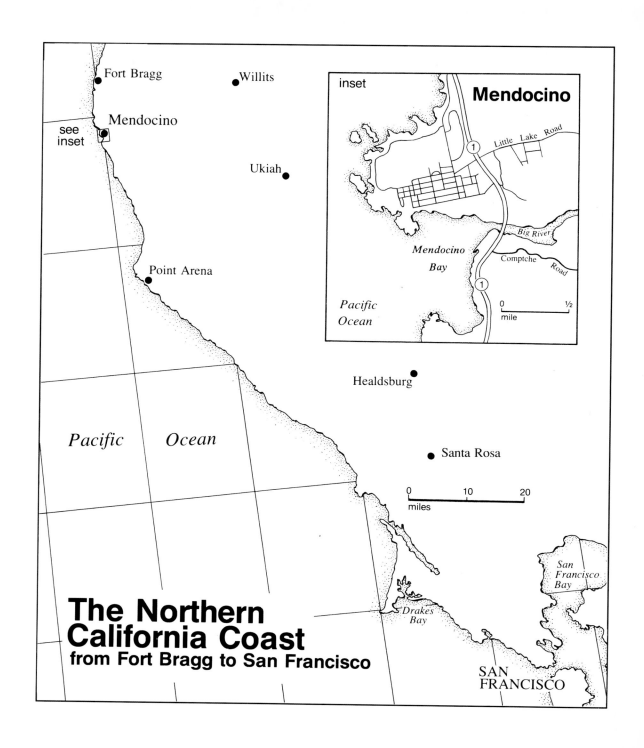

inset

Mendocino

Little Lake Road

Big River

Comptche Road

Mendocino Bay

Pacific Ocean

0 ½
mile

Fort Bragg

Willits

Mendocino

see inset

Ukiah

Point Arena

Healdsburg

Pacific Ocean

Santa Rosa

0 10 20
miles

San Francisco Bay

Drakes Bay

The Northern California Coast
from Fort Bragg to San Francisco

SAN FRANCISCO

David Gregory studied art and architecture at the University of Illinois at Urbana. After an ardent eight-year courtship (on his part), he and Georgia-Ann were married and spent their honeymoon in Mendocino. It was then that he decided to become a full-time artist. His style, described by John Pence (of San Francisco's John Pence Gallery) as "precise and pristine" lends itself perfectly to the architecture and scenery of Mendocino. His oils and watercolors have been exhibited in major galleries in California and his native midwest.

John Bear and his family settled in Mendocino after a career in which he was an executive at Bell & Howell and Midas Muffler, a professor at the University of Iowa, and Director of the Center for the Gifted Child in San Francisco. He has had 23 books published by major publishers. In 1960, he purchased a dozen M. C. Escher originals from the artist for $50 each. He wishes to state, for the record, that he fully believes his small collection of Gregories will turn out to be as good an investment in both a business and aesthetic sense.

If this were a movie, not a book, **Georgia-Ann Gregory** would be the producer, the director and the set designer. It was she who set aside her ministerial interests to bring the artist and the author together (happily they had respect and admiration for one another's work); it was she who organized the partnership that made production of the book financially possible; and it was she who put in countless hours in the process of design and production, working with photographers, typographers, and with the printer in Singapore.